IMAGES
of America

MOUNT VERNON
REVISITED

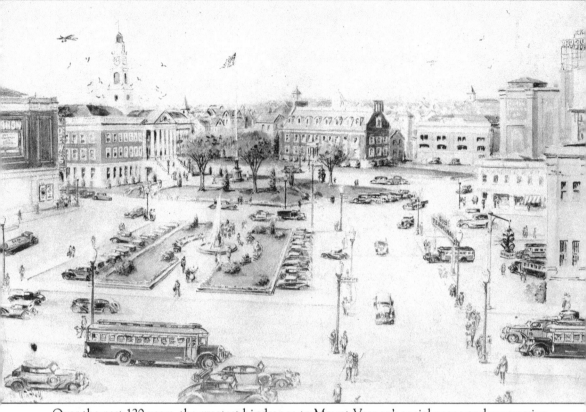

Over the past 120 years, the greatest hindrance to Mount Vernon's social peace and progressive development has been the ill-advised digging out and lowering of the New York–New Haven Railroad track from 1892 to 1895. It created a century-long scar stretching along First Street through the heart of the city. Within a decade, the good intentions of the complicated engineering project were recognized as a municipal error destined to change the city's character and image. Mount Vernon has been portrayed as a tale of two cities: the more prosperous and monolithic north side, and an impoverished, urban south side. From 1905 to the present, there have been numerous plans to cover "the cut." This 1935 illustration was part of a third wave of unsuccessful plans to build over the tracks. "The cut" remains a major obstacle to Mount Vernon redevelopment. It is at the center of the city's hope for redesign and reconstruction by the time of the 2053 bicentennial. (Courtesy of the Mount Vernon Public Library, Virginia McClellan Moskowitz Local History Room.)

ON THE COVER: This north-facing 1949 photograph looks over the New York–New Haven Railroad tracks from South Fourth Avenue and First Street. It illustrates the 25-year transformation of the strip, from the congestion of trolley cars and automobiles and the clutter of power and telephone lines to this pristine setting. It represents a mid-century revival and reclamation of the "new suburban Mount Vernon." As the city approached the 1953 centennial celebration, storefronts were modernized, streets were widened and repaved, and poles and wires were removed. The Lucas Building (top right), at the northeast corner of Fiske Place and Gramatan Avenue, once served as city hall. (Courtesy of the Mount Vernon Public Library, Virginia McClellan Moskowitz Local History Room.)

IMAGES
of America

MOUNT VERNON
REVISITED

Dr. Larry H. Spruill
and Donna M. Jackson
Foreword by Mayor Ernest D. Davis

ARCADIA
PUBLISHING

Published by Arcadia Publishing
Charleston, South Carolina

Library of Congress Control Number: 2013952755

For all general information, please contact Arcadia Publishing:
Telephone 843-853-2070
Fax 843-853-0044
E-mail sales@arcadiapublishing.com
For customer service and orders:
Toll-Free 1-888-313-2665

Visit us on the Internet at www.arcadiapublishing.com

*To our parents, Leamon and Wealtha Spruill and Henry and
Georgia May, who planted the seeds of historical curiosity and
community-based intellectual activism in our lives while encouraging
us to pursue public history without certainty of material reward.*

CONTENTS

FOREWORD

My architectural and planning background allows for an intense appreciation of the efforts of our city's founder, John Stevens. Out of Eastchester farms and forests, he crafted one of the first planned communities in the United States. His achievements over 150 years ago reverberate, exciting my passions. At the midpoint of my fourth term, I remain a steadfast believer that the ingredients that guided our past have blazed a path to the future.

A strategically located small city, Mount Vernon embraces the new millennium with renewed energy, embarking on an achievable, common vision. In 40 years, we will celebrate the city's bicentennial. What kind of city will Mount Vernon be? What shape will its character and aesthetics take? Will our city continue to be livable and affordable? These questions are at the heart of our aspirations to leave a meaningful legacy for our great-grandchildren and future residents.

In a rapidly changing Mount Vernon, the past provides a reliable lens, dependable evidence of where we have been, and a clear guide toward community prosperity and peace. Our heritage indicates how much we have achieved and what remains to be done.

Cities are about community—and people. Within that community are social organizations experiencing natural ebbs and flows. Mount Vernon is no exception; we have within our history a dynamic stream of events and personalities that have helped to shape our course.

Though our city is only 160 years old, it began as one of the first American communities explicitly planned and designed to enable middle- and working-class people to have an affordable home of their own. Today, we are a blended small city with four square miles of multicultural, middle-class neighborhoods. We are not exempt from the realities plaguing cities across the nation. Sectors of our community are plagued with difficult, entrenched urban problems.

Mount Vernon Revisited is unique and encouraging, because it offers our 70,000 residents an opportunity to initiate a needed conversation about how those who came before us responded to controversial and challenging times. It provides a common ground for the development of civil discussions, mutual understanding, and planning among an uncommon people. This book dares us to look beyond the urban crisis and to collectively pursue a progressive direction for the balance of this century.

Mount Vernon cannot simply adopt the developmental traits of neighboring cities. As the authors reveal, we have our own path. Mount Vernon's future is connected to the creation of a new model of urban and suburban development that combines the power of diversity with the middle-class values and dreams of its 19th-century founders.

Like John Stevens, I have been committed to laying new structural foundations for the city. *Mount Vernon Revisited* is confirmation of my "Stevensesque" 21st-century vision. The book shares a compelling view of what is possible if we are innovative, courageous, and united. This publication visualizes a municipal process of what happens when cities are committed to community planning that recognizes the importance of allowing its past to inform its present while planning for the future.

I am grateful to our city historians, who have initiated this timely discussion in this important publication. There comes a time in the life of every city to see where it has been, where it is now, and, especially, what it might look like in a half century. Dr. Larry Spruill and Donna Jackson have provided such a moment.

As I continue to propose new directions for our city, I encourage residents and those interested in the future to read *Mount Vernon Revisited*, an introspective tool on the city's past and future.

—Ernest D. Davis
Mayor, Mount Vernon, New York

ACKNOWLEDGMENTS

Mount Vernon Revisited could not have been possible without the collaboration of the Mount Vernon Public Library and the staff at the Virginia McClellan Moskowitz Local History Room. This project is indebted to the city's Paul Caramuto photographic print collection, the negatives and prints from the Rufus Merritt Studios, and the archives of the *Westchester Observer* weekly newspaper. We are grateful for the generous assistance of Katie Hite and Patrick Rafferty of the Westchester County Historical Society (WCHS) and appreciate the resources, suggestions, and encouragement from Dr. David Osborn of St. Paul's Church National Historic Site. Their guidance and access to public and private archives and photographs was most helpful. We would like to thank William "Billy" Thomas for his pictures from the Mount Vernon Boys & Girls Club; William Branca for permission to use photographs from the Branca family archive; the late Ruth Levister for her unique family images; the archivists at Grace Baptist Church, Unity Baptist Church, and Centennial AMEZ Church; William Sullivan for use of images in the AC-BAW Center for the Arts permanent collection; and, finally, contributions from the Mount Vernon Planning Department. We especially appreciate Rebekah Collinsworth, Arcadia project editor, for recommending a second volume of *Historic Mount Vernon*. Finally, we are grateful for our families for understanding our passion for all things Mount Vernon. Thanks Doris, Michael, Hassan, Mikeshia, Miriam, Brandon, and Brendon; and Damon, Zuri, Layla, Derrick, Carla, Henry W., Henry A., and Audrey June for sharing us with *Mount Vernon Revisited*. Unless otherwise noted, all images appear courtesy of the Mount Vernon Public Library Virginia McClellan Moskowitz Local History Room.

INTRODUCTION

Although the township of Eastchester (1664) was among the earliest Westchester settlements, no village of noticeable pretensions had arisen until the 1850 founding of Mount Vernon. John Stevens and the Industrial Home Association No. 1, composed mostly of shopkeepers, skilled tradesmen, and people of modest means, organized to escape New York City's high rents to become suburban home owners. Stevens was interested in a new settlement 30 minutes from New York City by boat, train, or stagecoach. He chose an Eastchester site at the intersection of the New York–New Haven and New York Central Railroads.

Building a new city on New York's rural doorstep was a formidable task. The association purchased five farms totaling 370 acres for $75,000. On January 10, 1851, the settlement was named "Mount Vernon." In the spring, the village was laid out into streets and avenues, and a train depot was erected. By the end of the year, 36 houses had been built. By August 1852, the number had increased to 300. In December 1853, a majority of citizens voted for a hotly contested plan for incorporation. On March 7, 1854, five village trustees were selected to serve the 1,370 inhabitants.

During the same time as the founding of Mount Vernon, the Teutonic Homestead Association, composed principally of Germans, established a town, West Mount Vernon, building houses near the New York Central Railroad along the Bronx River. A third settlement, Central Mount Vernon, was formed between the two existing communities. The three were consolidated in 1878. John Stevens died in 1882. After 29 years of rapid growth, the village of Mount Vernon became a city in 1892.

Revisiting Mount Vernon's origins and progress requires a review of John Stevens's biography. Traditionally seen as a romantic reformer, new documents reveal that Stevens was not merely an ambitious "merchant tailor." His previously unquestioned social background has become surrounded in myth. He undoubtedly cared about middle- and working-class people and their desire to become home owners, but his distinguished personal life was more affluent and privileged than previously known.

Though Stevens was born and died in New Jersey and buried in the Bronx, he is often referred to as the "Father of Mount Vernon, New York." Little is known of his family upbringing, the source of his bold ambitions. His remarkable genealogy answers long-standing questions about his motivations and self-confidence. His uncommon entrepreneurial spirit was admirable, but not without personal precedence. A person with sterling character and experience was necessary to inspire 1,000 families to invest in this risky homesteading venture. A closer look at Stevens's pedigree reveals that he was a noteworthy man from an extraordinarily privileged, well-educated family of economic, political, and technological greatness.

John Stevens was a direct descendent of four generations of men bearing the same name. He was born into an influential, landed aristocratic New Jersey family that had partaken in and benefited from the American Revolution. The name John Stevens can be found among the elites who founded the United States and helped establish the nation's prominence among the great 19th-century European powers.

The Stevens family was one of America's early engineering and technological dynasties. From their Hoboken estate, they designed and built prototypes that became modern railroads, trains, and trolleys, steam-powered water vessels, and automobiles. In 1809, his uncle, John Stevens III, built a steamboat that sailed from Hoboken to Philadelphia, becoming the first steamship to successfully navigate the open ocean. In 1811, another Stevens ship began operation as the first steam-powered ferry service between New York City and Hoboken. In 1815, the first railroad charter in the United States was given to Stevens III for the New Jersey Railroad. Railroads, steamships, and even engine-powered carriages (automobiles) were embedded in the family's heritage.

The great aunt of Mount Vernon's John Stevens, Mary Stevens, married Robert Livingston, who partnered in 1807 with Robert Fulton and built the *Clermont*, the first commercial steamboat. It sailed up the Hudson River from New York City to Albany, carrying passengers the 150 miles in 32 hours, which normally took a week. Fulton and Livingston were close friends and associates of John Stevens III. Transportation technologies were a Stevens family legacy. Stevens Institute of Technology in Hoboken was the consequence of gifts from a long line of men named John Stevens.

The city's "founding father" was a son of America's most prestigious family of engineering visionaries. The establishment of Mount Vernon enabled John Stevens to create a laboratory for pragmatic application of modern transportation technologies and to test their impact on people, commerce, and cities.

Stevens's full biography explains why, from the beginning of Mount Vernon, mass transit was central to its evolution and success. Equally important is an understanding of the city founders' great interest in obtaining jurisdiction over Eastchester Creek and its connection to Long Island Sound. Just as the New Jersey Stevens family founded Hoboken, with its access to the Hudson River and New York City, acquisition of the lowly tidal waterway at Mount Vernon's southern borders would provide similar access to New York. From its village origins, Mount Vernon expected to one day control Eastchester Creek and use it as an all-water route to Greater New York. Federally funded dredging and channel-deepening projects along the creek began as early as 1873, and they were not completed until 1941.

In 1898, Bronx County was created, and new boundary lines with Westchester County were drawn at Eastchester Creek, giving Mount Vernon jurisdiction over the waterway. The acquisition was the realization of Mount Vernon's dream to transform the tidal stream into a deepwater port capable of landing construction and industrial supplies as well as storing coal, wood, and, later, the 20th-century fuel of choice, petroleum. The speculative idea of oil storage and distribution facilities along the creek was essential to the promise of unlimited wealth from industrial development. It began a major shift from the stability of suburban lifestyles. By 1940, Eastchester Creek was a major port for petroleum barges unloading fuel into massive storage tanks along its banks. "Oil City" was born, and it forever changed Mount Vernon. By the 1960s, Oil City was in decline. The promise of unprecedented industrial profits was not realized.

Mount Vernon's short-lived suburban perfectionism began to change while Stevens was alive. He did not see the village become an incorporated city (1892), or the annexation of Eastchester Creek (1898). Between 1900 and 1925, politicians laid the foundation for the city's embrace of industrial development on remaining vacant lands, especially near the creek and the Bronx River. Over the past century, scarce real estate assets were lost to earlier unbridled industrial and urban ambitions.

From 1892 to 1950, the social redefinition of Mount Vernon was initiated by the importation of Italian immigrants to work on the massive project lowering the New York–New Haven Railroad line as it passed through the center of the city. They were considered cheap foreign labor, often treated as a despised minority. They worked hard, successfully pursuing the American Dream. The Italian population grew, outpacing all other ethnic groups. They organized the Italian Civic Association in 1917 and became a socioeconomic and political contender that shaped the balance of the 20th century. By the 1953 Centennial Centurama, a son of an Italian immigrant was mayor, and others served as aldermen, school trustees, and city officials.

During the second half of the century, a similar migration experience took place among Southern African Americans. From 1955 to 1985, African Americans and Caribbean immigrants were the fastest-growing demographic. By the mid-1960s, they began to challenge the institutionalized Italian American status quo. The last half of the century was often a period of contentious transitions. The 21st-century increase in Hispanic and Portuguese residents continues to define Mount Vernon.

Mount Vernon Revisited provides historical images and words that help explain the dynamic forces that shaped and created millennial Mount Vernon. It facilitates a citywide conversation around the question, "Where do we go from here?" The newest residents are unfamiliar with the

decades of social and economic successes and the struggle to overcome the negative impact of postindustrial American life.

Mount Vernon is a proud city with a great history. Extraordinary cities evolve and are resilient. The best place to look for municipal hope is the future. Now is the time to look back, assess the present, and move forward. Mount Vernon will rebuild its infrastructure, economy, and social fabric. The city will restore the roles healthy families, world-class schools, vibrant businesses, reform-focused houses of worship, and community-based organizations play in progressive cities. Real change is "real hard." It requires vision, determination and capital.

Mount Vernon Revisited inspires readers to support the difficult work of reimagining and rebuilding the city. It identifies history-driven projects that might be accomplished by 2053. Over the next four decades, it will serve as a resource to review the people, policies, and events that made Mount Vernon an enviable small city. It offers reflective opportunities to look at how far it has come. It allows past and present residents to see the city afresh. More important, *Mount Vernon Revisited* provides a hopeful view of our past and present in ample time to determine the direction and measure the distance residents must yet travel. Enjoy!

—Dr. Larry H. Spruill and Donna M. Jackson

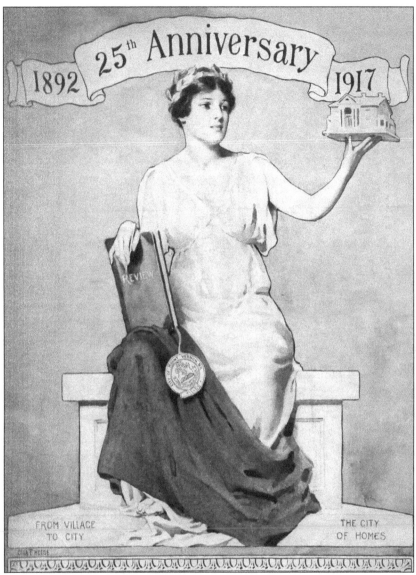

In 1917, Mount Vernon celebrated its 25th anniversary as an incorporated city. This journal highlighted its progress. On the cover was "Columbia," the female personification of 20th-century America. She held up a sizeable house and had a new city seal on her lap. Though the symbols projected the ideals of the village founders, Mount Vernonites saw their growing city as a mirror image of the modern industrial nation. The 1853 founders' vision of a suburban village of spacious homes on quarter-acre lots was well on its way to becoming a complex urban community with an expanding, diverse population and an industrial economy. In 1942, the city celebrated the 50th anniversary by extolling the progress made towards its commercial and industrial goals. By the time of the 1953 village centennial celebration, the city had built a complex of five 10-story, low-income, high-rise apartment buildings. Its governance significantly shifted to the sons of Italian immigrants. By the time of the 1992 city centennial celebration, Mount Vernon was no longer an elite Westchester suburban community. In 2003, there was a limited sesquicentennial celebration. In the next half century, Mount Vernon will seek to reinvent and re-brand itself with three milestone opportunities (in 2017, 2042, and 2053) to revisit the city's heritage.

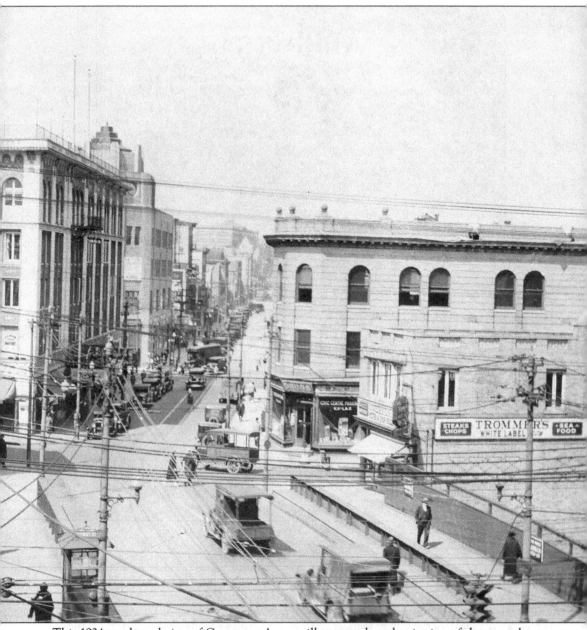

This 1924 northward view of Gramatan Avenue illustrates the urbanization of the once-sleepy village of Mount Vernon into a congested modern city. On the right is the two-story Lucas Building, which served as city hall. By mid-century, the "economic section" of the Westchester Women's Club had successfully completed a two-decade campaign to return the city to its suburban roots by its 1953 centennial celebration. The 1949 photograph on the cover shows this same view 25 years later.

One

BACK TO THE FUTURE

In 1892, Mount Vernon rejected absorption by New York, chose incorporation, and became an independent city. It adopted the motto "City of Happy Homes." By its 50th anniversary, there were 4,000 homes and more than 30 miles of paved streets. It had 1,000 streetlights, 460 fire hydrants, and 40 miles of sewer lines. There were three banks, four hotels, a hospital, 10 public schools, five private schools, a new public library with 11,000 books, and a new post office to handle increased daily mail. There were four newspapers, a public park, four public halls, an opera house, and a palatial theater under construction. The police force included a chief, two sergeants, and 23 patrolmen. The 300-man volunteer fire department was divided into 12 companies, housed in advanced firehouses. Along with its citywide alarm system, the department was considered the best in the county.

There were two railroad depots serving 134 daily trains to New York. There were trolleys to Manhattan, Yonkers, White Plains, and Port Chester. Mount Vernon offered water-freight transportation to New York on Eastchester Creek. Its greatest asset remained its location, just 30 minutes from Manhattan.

The city's services were telephone, gas, electrical, water and sewage (including indoor plumbing and hot water), and automotive. Mount Vernon's success attracted shopkeepers, artisans, intellectuals, artists, scientists, and bankers spread throughout the region. It also drew impoverished Southerners and foreign immigrants seeking opportunities. There were three lumber and home-construction firms with extensive yards and well-stocked warehouses and factories. It was home to a brewery and factories, lured from New York, manufacturing guitars, shirts, horse carriages, and garments. In 1912, there was an electric automobile factory with a charging station.

By 1920, Mount Vernon was a modern city. An observer wrote, "The growth and prosperity already attained by Mount Vernon leads to a reasonable belief that it will surpass its previous record in the years to come, it appears inevitable that it will be absorbed by the great metropolis." Annexation to Bronx County never happened, however; the city was influenced by its neighbor's urban ways. For the balance of the century, "The City of Happy Homes" was gradually redefined as an "inner city." After 160 years, Mount Vernon is at the crossroads of its hopes for the reconstruction of a new "Four Square" by 2053.

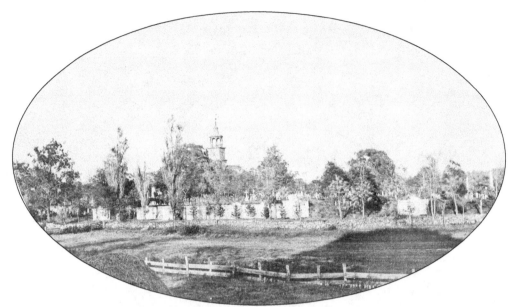

The photograph above, taken in 1865, looks southeast from South Third Avenue. Shown here is St. Paul's Church and Cemetery, a National Historic Site. Covering more than five acres, the cemetery contains an estimated 9,000 burials. This 17th-century burial ground provides unique insights into the heritage of Eastchester, Mount Vernon, and Westchester and Bronx Counties. The Vincent-Halsey-Smith House (below) is a Revolutionary-era dwelling located across the Bronx line. It was owned by William and Nabby Adams-Smith, son-in-law and daughter of John and Abigail Adams. In 1797, due to a cholera epidemic, President Adams could not journey to the capital in Philadelphia. For one month, this home was the official "White House." Abigail Adams attended St. Paul's Church while in Eastchester. (Above, courtesy of St. Paul's Church National Historic Site.)

The photograph above, taken in 1877, shows a family living at a house at Eastchester Bay, near Robert Reid's mill (1739). The narrow dirt road leading to the house and into the marshlands and salt meadows was known as Mill Lane. It was the oldest road in Eastchester other than the old Boston Post Road. Today, the massive Co-op City housing complex stands on the filled-in salt meadows. The photograph below, taken in 1865, shows a salt hay wagon returning from the marshes along Eastchester Creek. St. Paul's Church vestrymen gave the farmers permission to take their horses and wagons through the churchyard to cut the hay, which was used as feed for livestock. These people are passing through the eastern cemetery gate toward Route 22. (Below, courtesy of St. Paul's Church National Historic Site.)

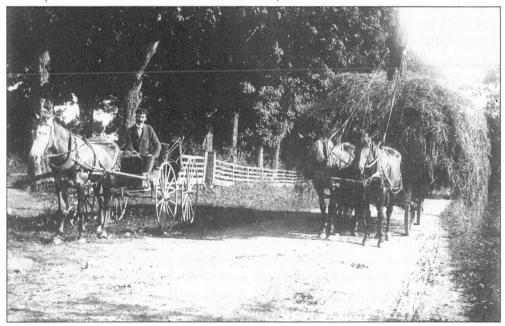

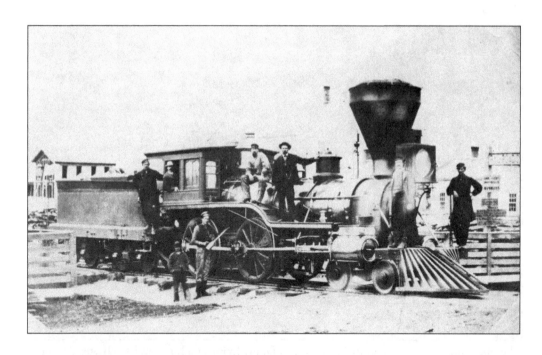

The photograph above shows an 1850 train used on the Harlem–New York Central and New York–New Haven Railroads. The two lines passed through Eastchester lands. The former line, which went to White Plains, had a Mount Vernon West station. The latter railroad, ending in Connecticut, had a Mount Vernon East station. In 1851, Mount Vernon village was laid out around rail lines along what is now First Street. The village agreed to give the railroad a plot of land for a depot, at Fourth Avenue and First Street, near Gould's Hotel. In return, the railroad promised to stop an agreed number of trains to and from New York City. Below is a rare drawing of the village portraying Mount Vernon in 1860. It is looking north from what are now First Street and Fourth Avenue, down Gramatan Avenue toward Fleetwood Avenue. It reveals the rural nature of the land across the street-level railroad tracks. It is the earliest view of what Mount Vernonites call the north side. On the left is Gould's Hotel. (Above, courtesy of WCHS.)

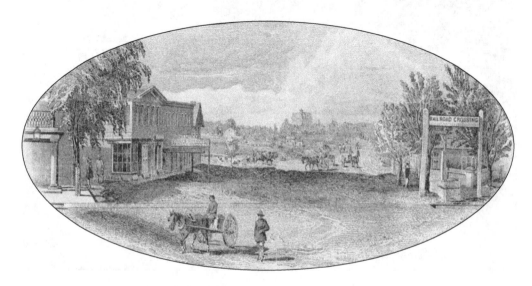

Mount Vernon became a unique small city neither by chance nor circumstance. John Stevens (right), born on April 17, 1803, in Elizabethtown, New Jersey, received the best education available at the time. On July 2, 1851, Stevens, his wife, Emeline, his sons George and John Oscar, and his daughter Mary moved to the new village of Mount Vernon. Today, most residents know his name from the Stevens House, at 29 West Fourth Street and Sixth Avenue, and Stevens Avenue, which runs parallel to the New York–New Haven Railroad and past city hall. Below is a photograph of the Andrew Purdy–John Stevens House (1842). It was sold to Stevens in 1850. In the rear was the barn, where 1,000 shareholders drew lots to determine the location of their quarter-acre lots on which to build their new homes. (Below, courtesy of WCHS and Gray Williams.)

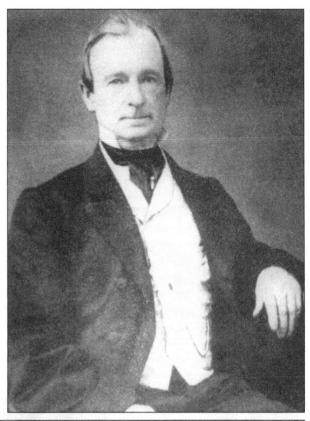

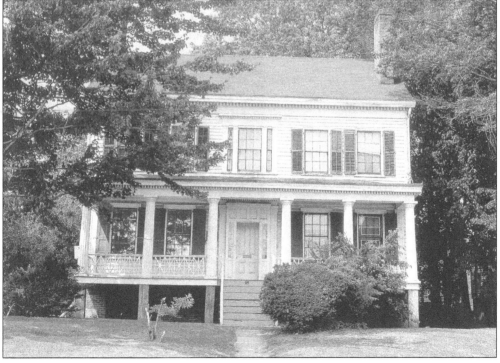

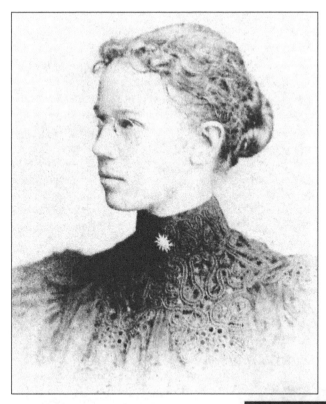

Shown at left around 1905 is Mary Louis Stevens-Miller, daughter of John and Emeline Stevens. Below is Mary Olive, daughter of Mandeville R. and Mary Louis Stevens-Miller. She was the Stevens's granddaughter. Her sister Louise Stevens Miller, who wrote a colorful history of growing up in the old house, died in 1948. Mary Olive was born on April 29, 1882, and lived in the Stevens House until her death, at age 90, on June 9, 1972. She was the last of Mount Vernon's founding family living in New York. Mary Olive Miller was buried in the Stevens family plot in Woodlawn Cemetery in the Bronx. She was a member of the First Reformed Church on South Fifth Avenue.

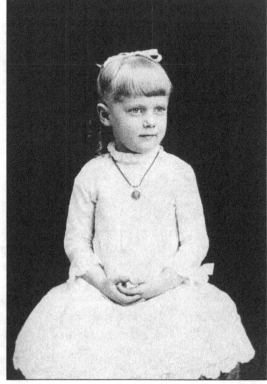

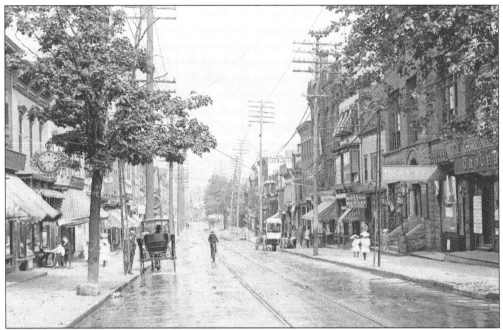

The photograph above, taken in 1889, looks north from South Fourth Avenue between Third and Second Streets. Trolley tracks are visible, and automobiles have not yet dominated the roads. The busy village was about to shed its swaddling cloth and become a bustling city. Edward W. Storms (below) owned a painters' supply store at 42 South Fourth Avenue. The 1890 photograph was taken at Fifth Avenue near Second Street. The street is unpaved and muddy. Sacred Heart Catholic Church is in the background.

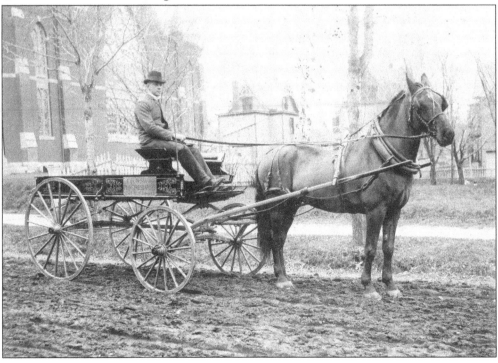

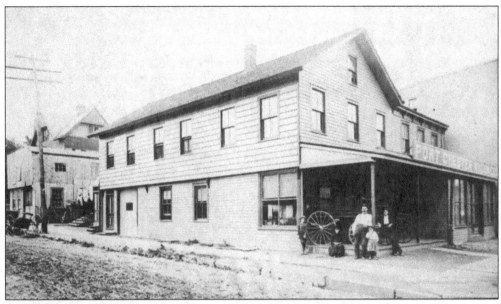

Above is an outbuilding of the old George Gould's Hotel (1875), located at what is now the northwest corner of Prospect and Gramatan Avenues. The hotel was closer to the railroad track and depot. It was the center of the community. Gould and his son Theodore owned most of the land west to today's city hall and north on Gramatan to Sidney Avenue. In front of this building, locals caught the stagecoach to Port Chester. The location is seen at left in 1947.

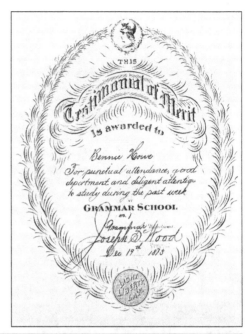

In 1873, Joseph Wood was appointed principal of School No. 1, on Fifth Avenue and Second Street. He later initiated the movement to build the first high school, the vocational and industrial school, school playgrounds, and the current public library. In 1935, School No. 1 was rebuilt and renamed Washington Junior High School. Shown above are student records of Benjamin Howe (right). He became the first Mount Vernon mayor (1907–1909) born, raised, and educated in the city.

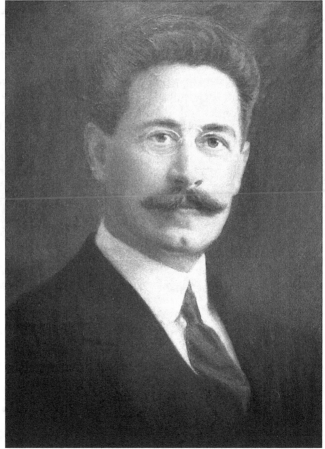

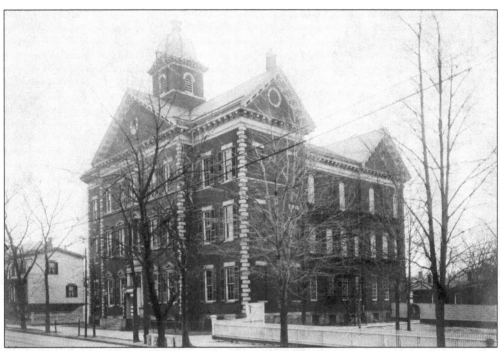

The photograph above shows School No. 1 around 1890. During the Great Depression, it was replaced with a modern building, paid for with federal funds. The construction created needed jobs. The state-of-the-art Joseph Wood Auditorium was part of the 1935 building project. For three decades, it was Mount Vernon's cultural center. Another federal school construction project was a new Nathan Hale School. Below, Cecil H. Parker (left) conducts a 1938 parent-school training workshop. There were few full-time teachers in the district as qualified as Parker, who had a BA from Boston University and an MA from New York University. In 1942, school board president Frank Nardozzi hired Mrs. Parker as a teacher at Nathan Hale. She became the first African American teacher in the city and county. Nardozzi and Parker were neighbors on South Ninth Avenue. On October 13, 1983, the school was renamed Cecil H. Parker Elementary.

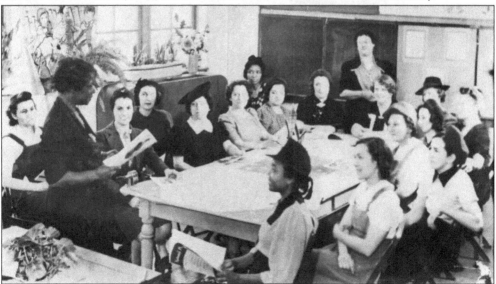

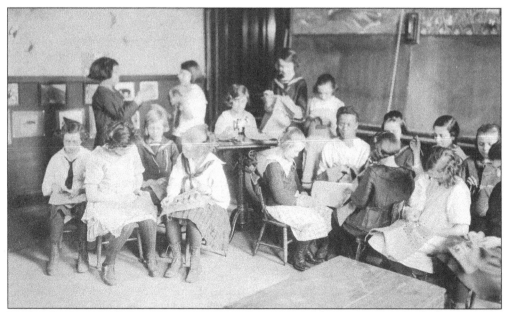

In the photograph above, taken in 1919, students are conducting an art class experiment in "Swedish weaving" at Washington Elementary School, on Fifth Avenue between Second and Third Streets. Elsie Lauricella and Anna Cuzzi are winding yarn. Isabel Silverstein is operating the sewing machine. From left to right, the other young ladies are Misses Drucher, Kneitel, De Marzo, Pryor, Johnson, and Donato. Below, Mount Vernon High School's German Culture Club poses in 1913. The Teutonic Home Association, founded in 1853 in West Mount Vernon, was mostly composed of German immigrants. Their settlement was along the Bronx River and the Harlem Railroad line, occupying the land adjoining the New York–New Haven Railroad. In 1878, the association joined East and Central Mount Vernon into a single village. They were proud of their culture and insisted German be taught in the schools.

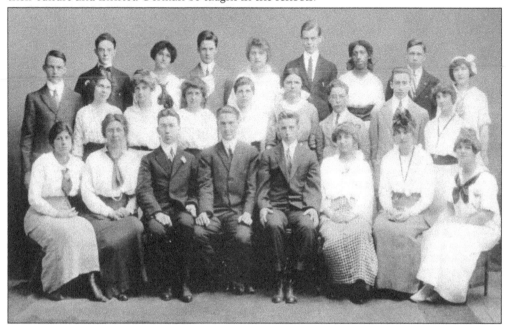

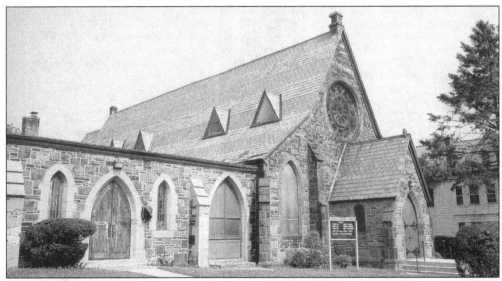

In 1851, villagers formed several church congregations. Eastchester's St. Paul's Church held services in newcomers' homes. In 1856, John Stevens was a lead voice for a new Mount Vernon Episcopalian church. The following year, three adjacent lots between Third and Fourth Avenues were donated. In 1859, the church was completed and dedicated as Trinity Episcopal Church (above). Between 1890 and 1930, the upper-middle-class Chester Hill neighborhood was developed. Its Methodists formed the First Methodist Church. In 1901, the Chester Hill Methodist Church was built and dedicated. By 1950, socioeconomic changes led to the decline of the First Methodist congregation, and, in 1967, it merged with the Chester Hill church (below). The renamed First United Methodist Church is located at East Lincoln Avenue and Summit Street. (Both courtesy of WCHS and Gray Williams.)

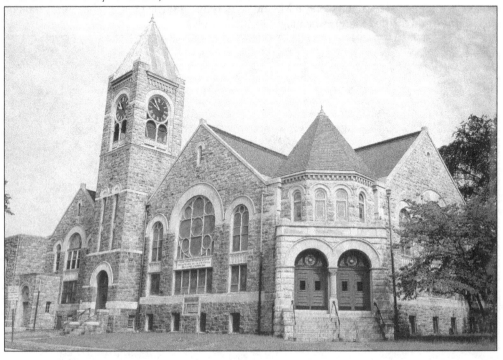

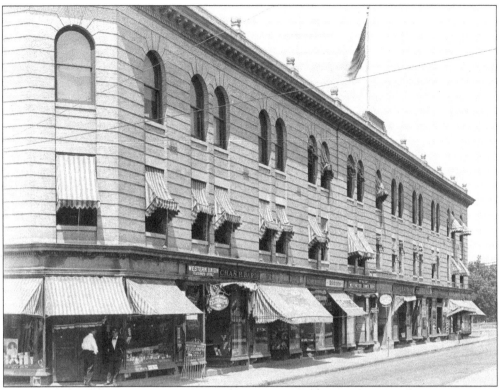

In 1929, Mayor James Berg opened the new city hall. It had been located in the Lucas Building (above), on Fiske Place near Gramatan Avenue facing the railroad "cut." The new building was on Stevens Avenue, on land designated as Roosevelt Square. It was constructed between the Fifth and Sixth Avenue bridges over the recessed railroad tracks. The 1912 postcard below of the railroad depot is a rare view of the rationale for "the cut." In the distance on the right with the flag flying on the roof is the Lucas Building. (Both courtesy of the Donna M. Jackson collection.)

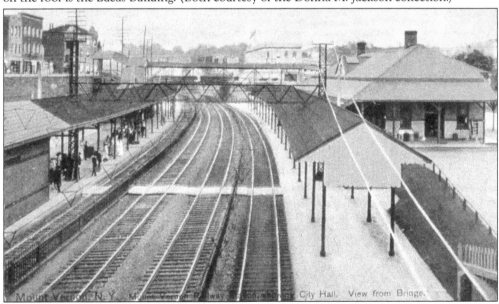

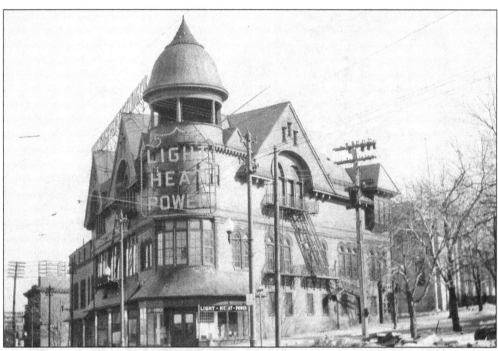

From 1900 to 1925, Mount Vernon's progress was reflected in several ways, including: electrical power, street and residential incandescent illumination, an adequate supply of clean water, indoor plumbing, municipal sewage, trolleys and mass transit, paved roads, telephone service, gas-fueled heating and cooking, motorized fire and police departments, and public works employees. The national craze for skyscrapers did not escape the city.

The construction of a new Westchester Lighting Company building (left), at the southeast corner of First Street and First Avenue, announced the city's arrival as a regional urban force. Today, it houses county government offices and services. Most citizens still refer to it as the Con Edison Building. The building shown above housed the electric company, but it was also known as Halifax Hall.

Two

Industrialization of the Suburban Dream

By the city's 25th anniversary, in 1917, its population had increased from 16,000 in 1892 to nearly 42,000. The four square miles could no longer offer newcomers a house on a quarter-acre lot. But Mount Vernon continued to market itself as "The City of Happy Homes." It built stylish apartments, multifamily dwellings for the well-to-do, and barracks for its increasingly ethnically diverse laborers.

In 1898, Eastchester's southernmost territory was ceded to Mount Vernon. The new Bronx and Westchester County border gave the city its long-desired port with access to Long Island Sound. Officials immediately exploited the shallow tidal creek, making it an industrial waterway. They believed that the future was not in the security of residential tranquility but in the ambitious pursuit of industrial and urban life. They sought the best of both worlds.

By the 1992 centennial, it was clear that this dual mission was not possible. The industrial sectors became part of the Northeastern "rust belt." Empty factories consumed valuable land needed for municipal redevelopment. The petroleum storage and distribution center along Eastchester Creek, called "Oil City," was bankrupt, abandoned, and dismantled. The expectation of unprecedented profits proved to be risky speculation at the expense of the original suburban goals. Similar unsustainable outcomes became the realities along West First Street and the Bronx River. The under performing industrial facilities on Washington Street also reflected the failure of the industrialization of the city.

In 1949, the new public housing authority built the Benjamin Levister Towers, five high-rise apartments for war veterans and low-income residents. Constructed on the south side of the cut, the buildings inevitably became predominately occupied by working-poor minorities. This began a half century of middle-class flight from the south side to the north and east sides. It slowly became a high-density community of minorities seeking the American Dream. As factories closed, industrial employment shrank, and the working poor were not able to enter the middle class. Aging housing stock, failing, segregated neighborhood schools, racially combative politics, a dwindling tax base, and the endless encroachment of urban elements from its southern borders meant that Mount Vernon gradually shed its suburban veneer. It was the end of the renowned "City of Happy Homes."

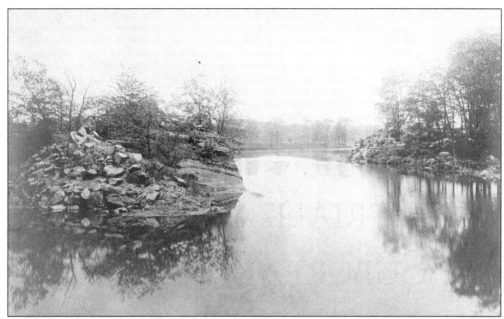

For millennia, the beauty and bounty of Eastchester Creek fed the area's Siwanoy Indians. As late as 1880, at high tide, it was the place where village boys spent their summer vacations, enjoying saltwater swimming and flounder fishing. The photograph above of the waterway meandering out to Eastchester Bay is a reminder of the legendary environmental health and recreational usefulness of the creek. From earliest times, lumber for house, barn, and fence construction was shipped to Eastchester by way of the tidal creek. Barges floated in with the flood tide, unloaded their cargo, and left with the ebbing flow toward Long Island Sound. Shown below is one of the late-1890s creek building suppliers.

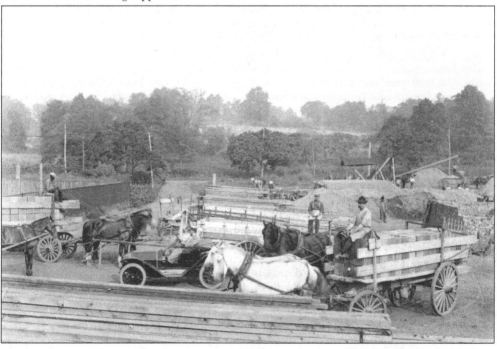

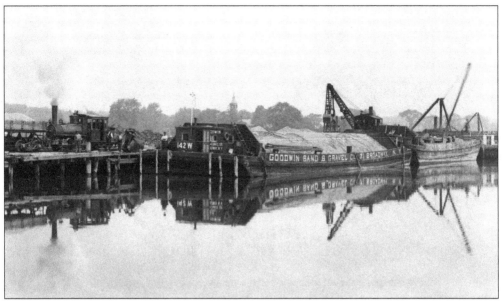

The industrialization of Eastchester Creek was dependent on unrestricted access to the dock by construction and heating fuel companies. The shallow stream was virtually dry at low tide. The delivery of sand, gravel, coal, and, later, oil to the dock for storage and distribution required straightening, dredging, and deepening of the waterway. Above, coal barges unload at the town dock. The photograph below shows Pruser's coal storage and distribution facilities at South Fulton and Edison Avenues. Both images are from around 1910.

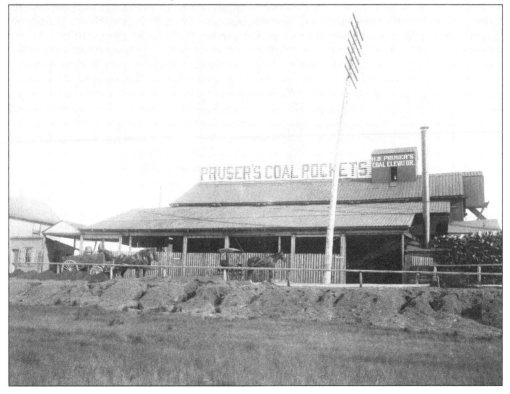

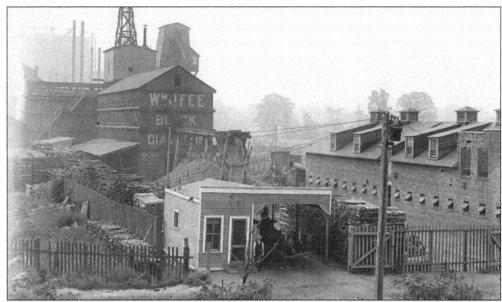

By 1910, most of the companies that stored and sold coal and wood recognized that new homes would not always be heated with coal. Firms such as William Fee (pictured above) and Pruser were preparing to sell the 20th-century fuel of choice—oil. By the 1930s, they laid the foundation for the renaming of the industrialized creek region as "Oil City." At the east end of Eastchester Creek is a canal that terminates at Hutchinson's Field. In the 1880s, Mount Vernon built an incinerator to dispose of the tons of garbage that the growing village was producing. The facility was a major polluter of the creek. By 1950, the stacks were bellowing thick black smoke and ashes into the air and water. Trucks collected nearly 2,000 tons of burnable material, and over 700 tons of ash were hauled to the city dump monthly. The incinerator is shown below on March 15, 1979.

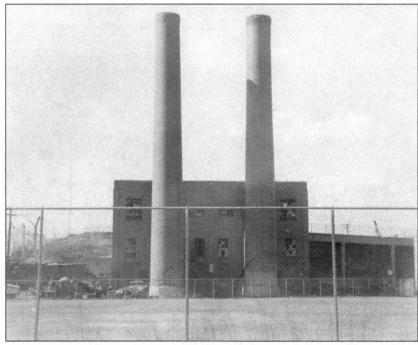

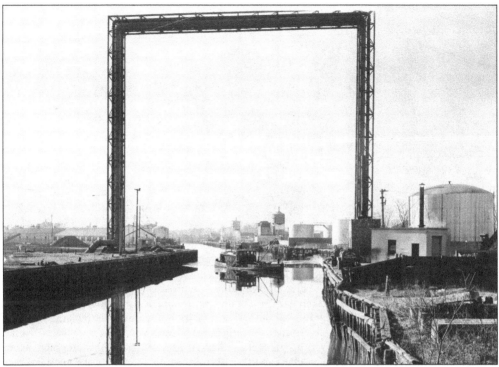

The photograph above shows the cargo hoist straddling the creek. Along with the oil storage tanks and the St. Paul's Church steeple, it became a signature of the murky and oil-slick waterway. Below, Fulton and Edison Avenues are seen during a 1954 flood after a storm tidal surge. The Pruser building (center) was still selling coal. At right, beyond the cars, is Fee Oil. The oil storage tanks are in the far background.

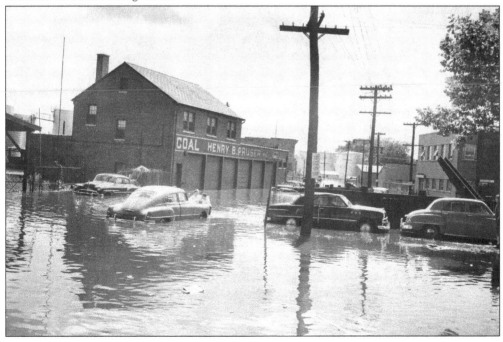

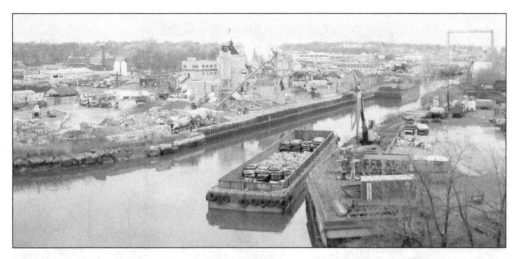

By 1940, approximately 27 million gallons of oil filled the steel tanks. Nearly 500 trucks carried fuel oil to neighboring communities daily. The creek was a busy industrial stream, and its economic impact was inescapable. By 1992, the giant tanks did not dominate the horizon or the economy. The 2011 photograph above was taken a short distance upstream, at the municipal incinerator. It is a dramatic view of the environmental devastation of the waterway. The reclamation and redevelopment of the creek is an urgent task for millennial Mount Vernon. On its south bank, Pelham has begun to do its share of rethinking of the industrial disaster. The 1910 photograph below is a view of Mount Vernon's small-city suburban life. This is the southeast corner of Fourth Avenue and Second Street. It is a visible reminder of the municipal conflict. In the midst of its industrial growth, the downtown's village charm was the last to succumb to its urban aspirations.

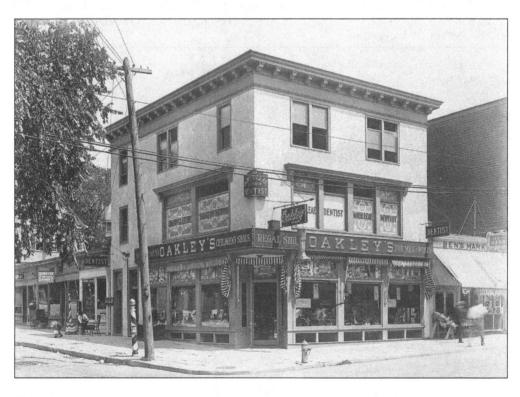

Edwin W. Fiske (right) served three terms as mayor (1896–1903, 1910–1917, and 1922–1924). The architect of urban and industrial Mount Vernon, he was the first mayor to occupy the Lucas Building as the city hall. The building stood at the corner of Fiske Place (named in his honor) and Gramatan Avenue. Fiske became the first and only Mount Vernon mayor to be nearly impeached. The corruption charge against him concerned a franchise for an industrial enterprise. In February 1899, the charges were dismissed. On June 3, 1928, Edwin Fiske died at his home (below), on West Second Street at the southeast corner of Ninth Avenue.

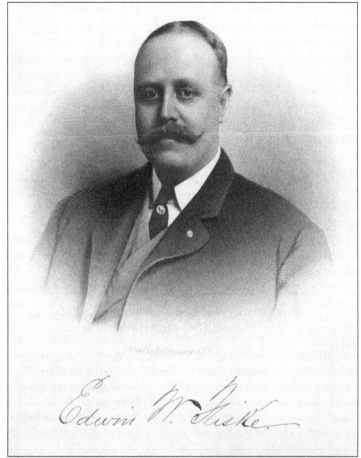

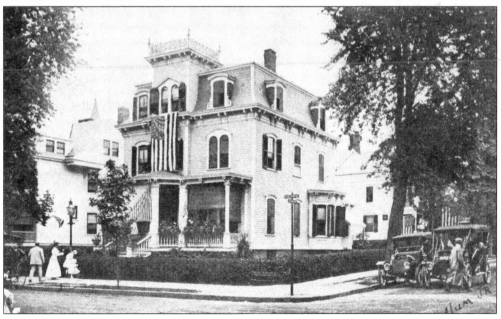

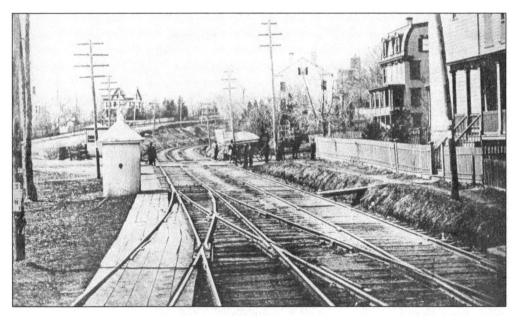

Shown above is a rare street-level photograph of the railroad tracks at First Street and Fifth Avenue. The commuter line was one of five major thoroughfares connecting Mount Vernon to New York and points east and north. In 1892, due to numerous pedestrian deaths, it was decided to lower the railroad tracks and build bridges spanning the "cut." Italian immigrants were employed to dig a 60-foot-deep cut (below) along First Street across the middle of the city. The cut forever affected people's perceptions of the city. In 1937, the *Daily Argus* wrote, "It seems almost inevitable that a city shall have locale known as 'the other side of the tracks.' In the case of Mount Vernon, the wrong side of the tracks has been the southwest sector known as the south side." In there past century, there were a number of proposals to cover the cut. It retains its stigma as dividing the city.

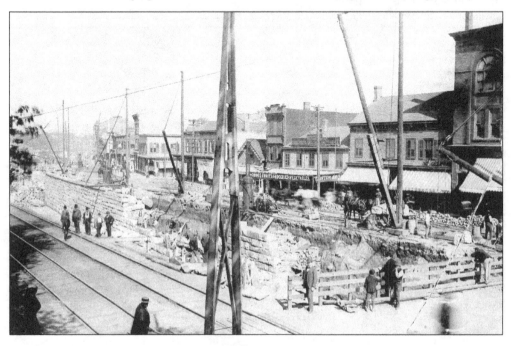

The New York–New Haven rail lines existed before the founding of Mount Vernon. The railroad cut stretches through the heart of the city. The seven bridges spanning the cut never unified the city, which remains divided, north and south. The 1929 photograph at right illustrates the reality of the breach. The 1974 photograph below highlights the useless, cavernous divide. It continues to support the idea that Mount Vernon's history is a "tale of two cities." The photograph, taken from the bridge at First Avenue, shows the aging rail line and the engineering difficulty of reuniting the city.

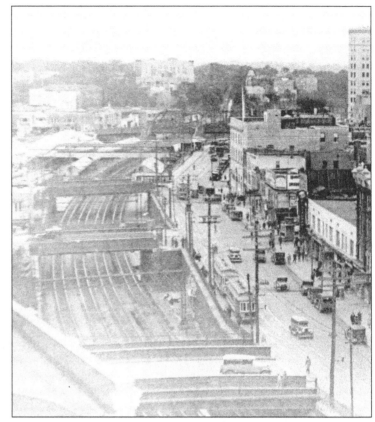

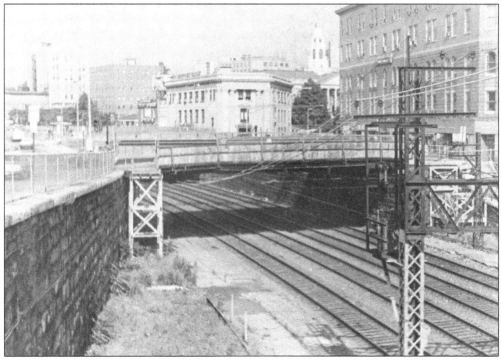

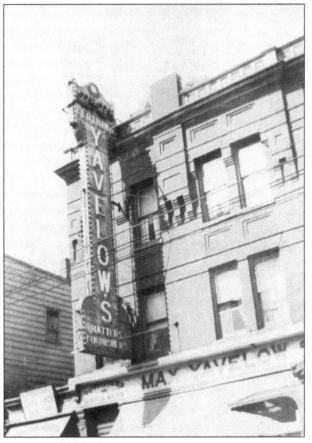

In 1890, Max Yavelow, a Russian immigrant, came to Mount Vernon to peddle goods to the army of workers lowering the railroad tracks. Walking to work and doing without food, Max saved $50 and opened a clothing store with his sons Abraham and Edward. By 1917, his original investment had grown into a $50,000 Gramatan Avenue business. Yavelow and Sons was so successful that, in 1926, it moved to the heart of the commercial district, at 128 South Fourth Avenue. In 1942, Max Yavelow died at his Bedford Avenue home. Shown above in 1946 from left to right are Abraham and Sadie Yavelow and Jennie and Edward Yavelow. In 1948, after 59 years in business, the brothers retired and closed the store. The store's signage (left) was taken down by the new owner when the building was sold. The hinges for the sign can still be seen on the building, now known as the AC-BAW Center for the Arts.

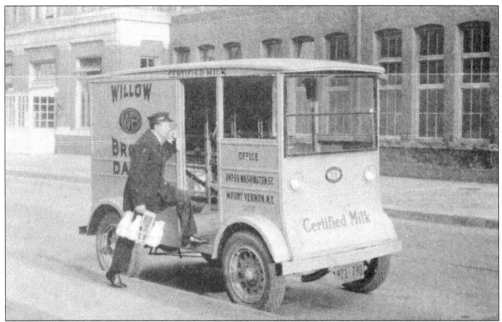

In 1914, the Charles A. Ward Motor Vehicle Company purchased a Mount Vernon site and built a factory with more than 50,000 square feet of floor space. Charles Ward pioneered the use of aluminum-body electric and gas automobiles. There were many electric trucks in use, but none were suited for light delivery services, in which speed and reliability were important. Ward's electric trucks, however, met these requirements. Above, a Ward-built electric milk truck made for the Willow Brook Dairy is seen on Washington Street in 1929. At the 1905 Madison Square Garden Auto Show, Henry Ford presented a car similar to one of Charles Ward's models. Ward and Ford spent several hours discussing the details of their cars. Ford gave Ward his friendly suggestions and approval. The car shown below, later made in Mount Vernon, was "blessed by Henry Ford." (Both courtesy of the Donna M. Jackson collection.)

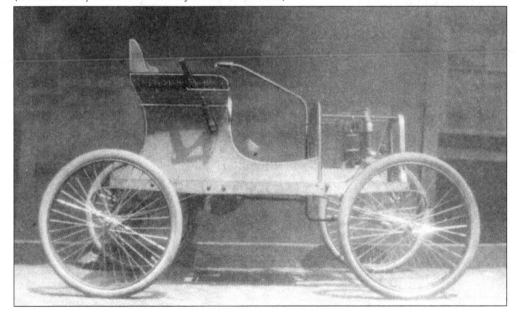

The Mount Vernon Public Library began in 1896 in an upper room of the Sophie J. Mee School, on South Fourth Avenue. In 1903, Andrew Carnegie gave the city $50,000 to erect the current building on First Avenue between First and Second Streets. The photograph above shows the library under construction in November 1903. The building was finished under budget and opened with a collection of 11,400 books. The circulation room, seen below in 1937, served in that capacity from 1926 to 1937. For more than 75 years, the Mount Vernon Library was the finest library between New York and Albany. Until recently, it served as Westchester's central library. The beauty of the building's walls, with the exquisite Louis Braun frescos, was recognized as an example of high art. The Mount Vernon Public Library was the literary and intellectual crown jewel of "The City of Happy Homes."

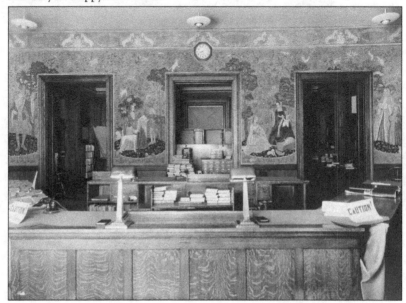

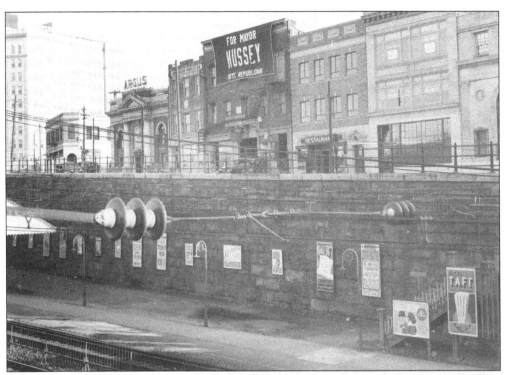

Seen above in 1940, the *Daily Argus* office (left of center) stood at the southwest corner of Second Avenue and First Street. From 1892 until the 1990s, it was the model hometown suburban newspaper, covering local news, politics, education, government, weddings, births, high school sports, church events, and businesses, as well as county, state, national, and international news. Frank Merriman (right) and co-owner Mark Stiles joined the paper with the city's fortune, making it a daily in 1892. For nearly 75 years, hundreds of boys and girls got their first jobs delivering the paper throughout the city. When the Gannett chain of regional newspapers purchased the paper, it lost its local focus and was never replaced.

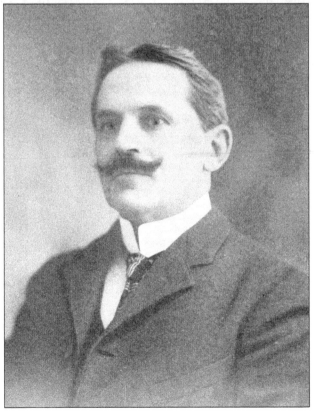

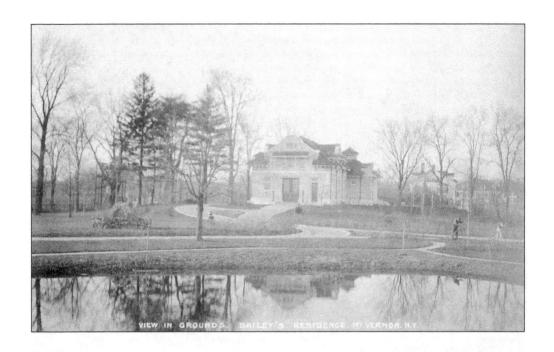

In 1881, James Anthony Bailey met P.T. Barnum, and they established the Barnum & Bailey Circus. Bailey, the backbone of the "Greatest Show on Earth," was an internationally famed entertainer known as "The Caesar of the Circus." He built a country estate in Mount Vernon. On April 11, 1906, after a week's illness with an obscure skin infection, Bailey died at his elegant Chester Hill home. His estate, The Knolls, is shown in the postcard above. In 1926, this palatial estate was auctioned for $1,900. The Park Lane Apartments, at Lincoln and Columbus Avenues, were built on the property. The 1884 photograph below looks north at South Fourth Avenue between West Third and Second Streets. (Above, courtesy of the Donna M. Jackson collection.)

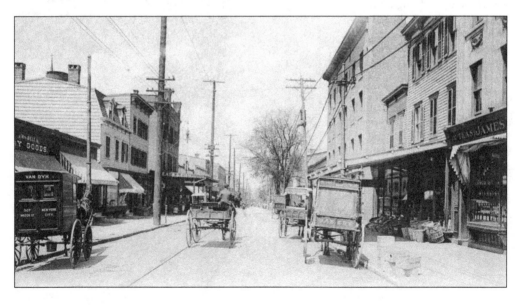

These two photographs offer a three-block survey, east to west, of First Street. In the foreground is the ever-present railroad cut. These blocks were on the "crossroad" of the city. The 1922 photographs were probably taken from the Proctor's Theater building, at Gramatan Avenue and Fiske Place. Shown above is First Street between Third and Fourth Avenues. The photograph below is of First Street between Fourth and Fifth Avenues. The faint steeple in the background is that of Sacred Heart Church.

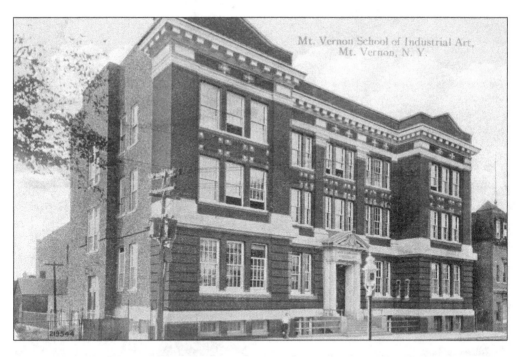

Shown on this page are, above, the Mount Vernon School of Industrial Art (1910) and, below, Mount Vernon High School (1912). The construction of these secondary schools reflected the shifting values of the "City of Happy Homes" from exclusive suburban values to an industrial and urban focus. In 1955, the community decided to build a comprehensive high school, combining the instructional programs of both schools. The school colors of Edison Technical (Industrial Art) were blue and gold, and A.B. Davis's (MVHS) were maroon and white. The colors of the new and current Mount Vernon High are maroon and gold.

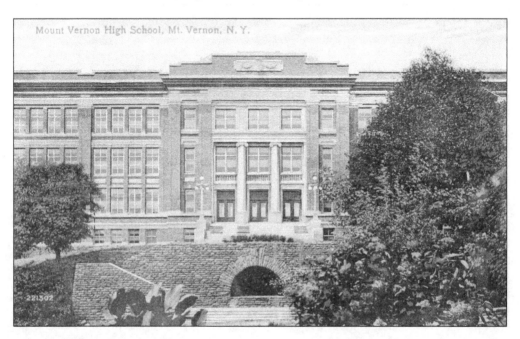

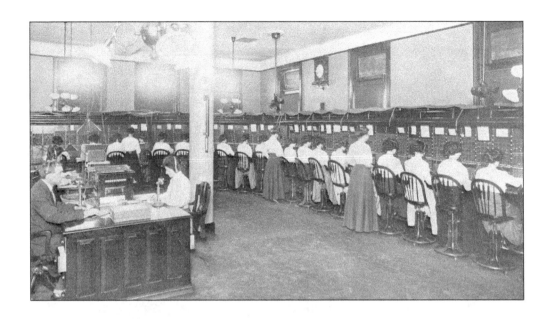

At the turn of the 20th century, life for women began to break away from traditional roles. It became fashionable for women to work outside of the home. Mount Vernon women eagerly embraced the social and cultural change. These 1911 photographs show "women's work" at the Mount Vernon Telephone Company, located on Fifth Avenue between First and Second Streets. They illustrate the presence of middle-class working women as operators, clerks, and tellers. Within a decade, they would finally win the right to vote.

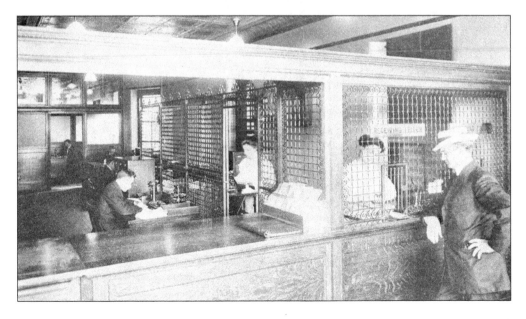

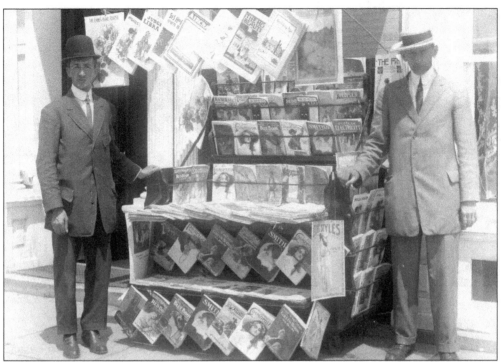

The First Street magazine stand shown above in 1911 displays an abundance of magazines addressing the "new" American woman. Mount Vernon women were among the most cosmopolitan in Westchester. The civic-minded Westchester Women's Club, then located on Crary Avenue, was the driving force for the city's first high school (1897), the construction of the public library (1904), local kindergartens, and a citywide network of playgrounds for all schools. The photograph below, also from 1911, shows a dress store at 32 South Fourth Avenue.

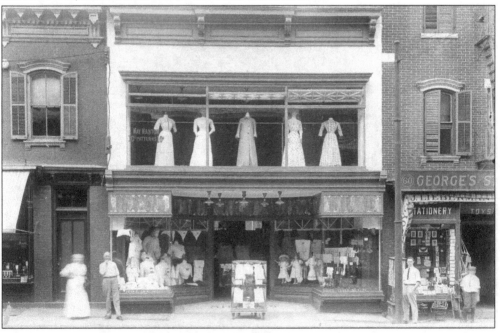

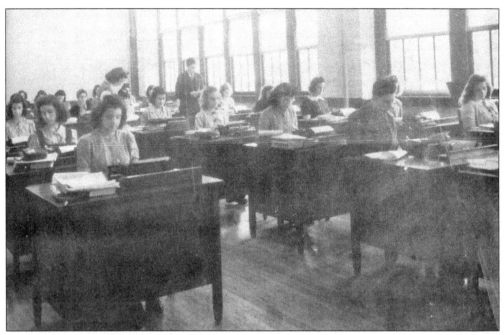

Shown above is a 1928 secretarial class at the technical high school. Young women were trained for employment in the local businesses and prosperous commercial economy. Below, in a 1919 industrial school class, women learn to be seamstresses. Such classes trained students for employment in the numerous garment factories lured to Mount Vernon from New York City.

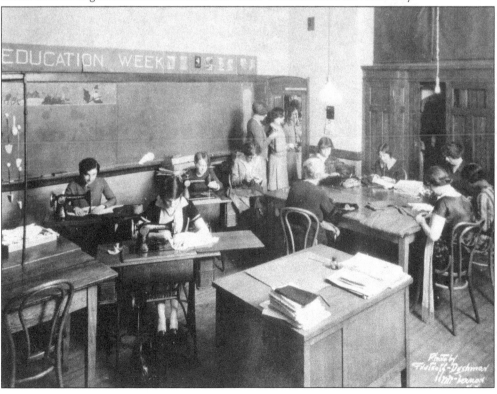

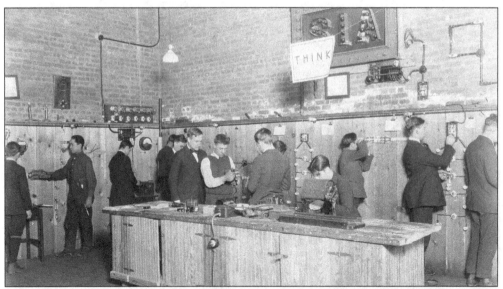

Mount Vernon schools took the path of providing comprehensive secondary education, which included high-quality college preparatory courses as well as the best vocational education for a city its size. Above, in 1942, these high school boys are being trained in the sciences. During World War II, young women were engaged in mechanical training. Many went to work in factories, sometimes replacing male workers away in the military. With many of the city's young men at war, Edison High School trained its share of "Rosie the Riveters." Mount Vernon High School had one of the finest vocational and technical education programs as late as 1995.

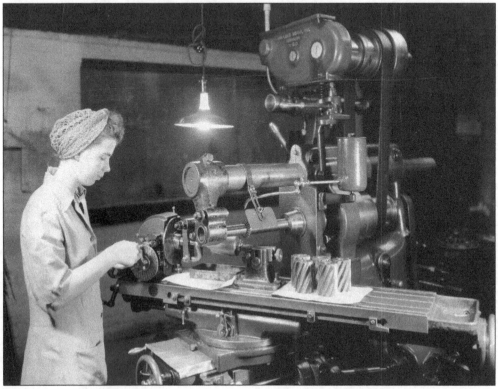

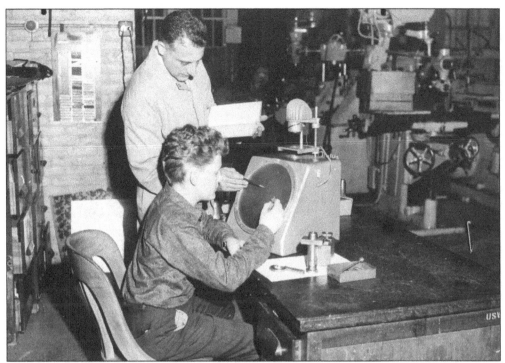

Mount Vernon Public Schools offered a two-track course of study to receive a high school diploma. In the 1940s, students at Edison Technical School and A.B. Davis High School had access to state-of-the-art vocational and scientific facilities. Both schools were recognized leaders in providing comprehensive curricula to their students. In the 1950s, contentious public hearings were held to build a single high school to serve both vocational and college-bound students. Below, a Davis High chemistry lab is seen on March 6, 1958. From left to right are Ann Armstrong, Fred Grossman, Dr. Arthur Taft, Frank Pierce, Dick Schwartz, and Abbott Noble.

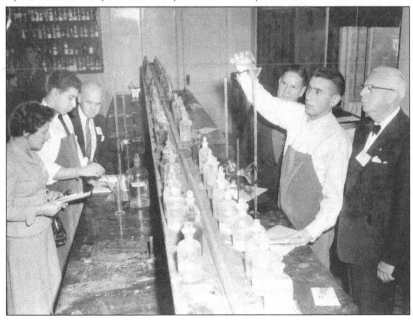

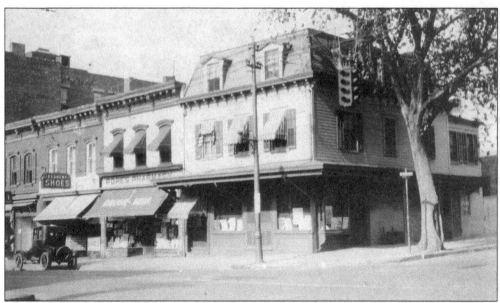

The northeast corner of South Fourth Avenue and West Second Street is seen here in 1924 (above) and 1947 (below). This intersection was the center of the downtown district. Between 1925 and 1950, the Westchester Women's Club addressed the decline of the business sector, launching a campaign to upgrade and modernize the shopping district. Store facades, window displays, sidewalks, and streets were refurbished, and wood-constructed buildings were forced to meet new city standards.

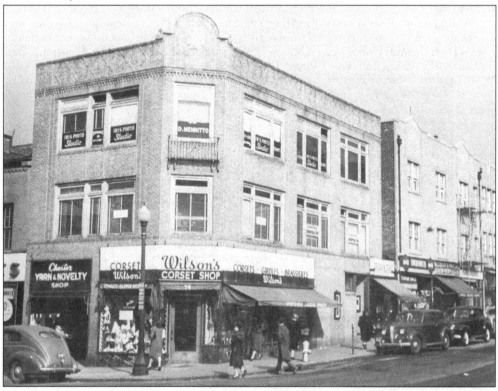

These two photographs show the southeast corner of South Second Avenue and West First Street, across from the New York–New Haven Railroad depot and tracks. The photograph at right was taken in 1924, and the photograph below in 1947. The Hotel Forum, the public library, the post office, the *Daily Argus*, the YMCA, and Westchester Power & Light (Con Edison) were clustered around this strategically located street corner. For years, the local Republican Party headquarters was on the second floor of the building shown below.

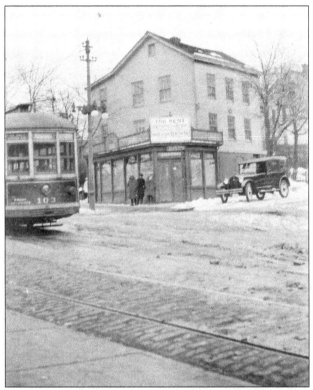

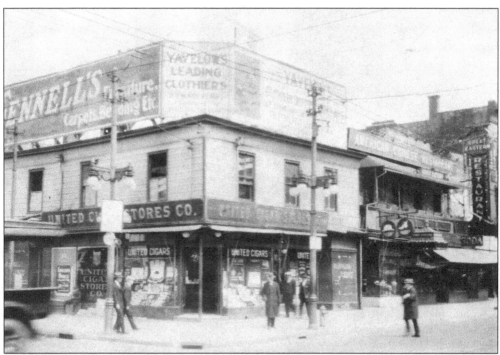

In the 20th century, Fourth Avenue between First and Second Streets was the most valuable real estate in the downtown shopping district. Like most preferred commercial property, its proximity to the confluence of mass transit was important. The southeast corner of Fourth Avenue and First Street was the most accessible downtown site. Trains, trolleys, and buses had stops near this corner, seen in 1924 (above) and 1947 (below).

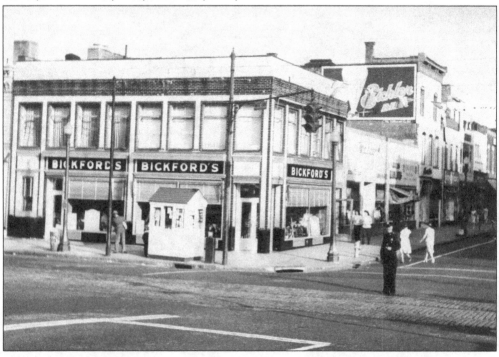

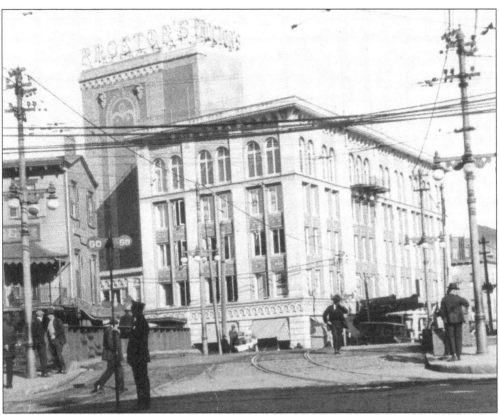

Above, across the Fourth Avenue bridge toward Gramatan Avenue, is the Proctor's Theater building, erected in 1912. In addition to its elegant theater, the structure had business, medical, and dental offices. By the 1970s, the shops across the bridge were preferred locations for small businesses. To the present day, Mount Vernon is perceived as a city with two separate business districts. Below is a 1935 rendition of a proposed transportation hub over "the cut." The Proctor's building is on the far right.

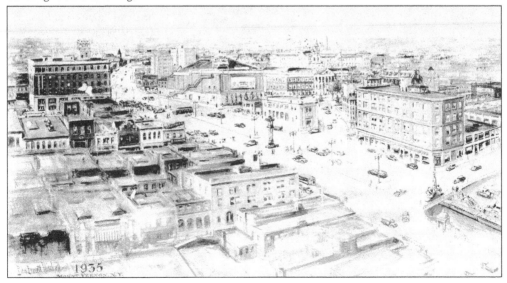

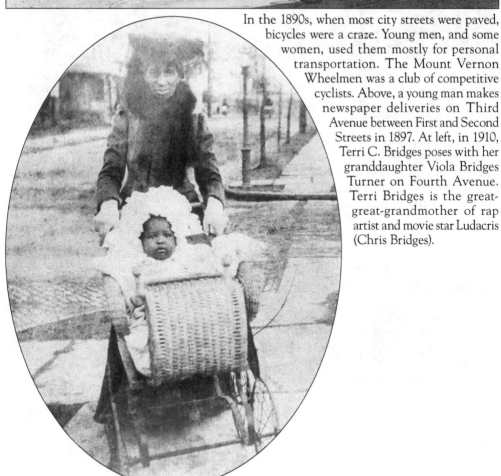

In the 1890s, when most city streets were paved, bicycles were a craze. Young men, and some women, used them mostly for personal transportation. The Mount Vernon Wheelmen was a club of competitive cyclists. Above, a young man makes newspaper deliveries on Third Avenue between First and Second Streets in 1897. At left, in 1910, Terri C. Bridges poses with her granddaughter Viola Bridges Turner on Fourth Avenue. Terri Bridges is the great-great-grandmother of rap artist and movie star Ludacris (Chris Bridges).

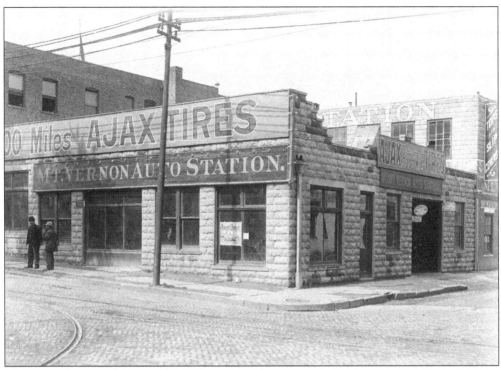

The Bronx River Parkway (1924) and Cross-County Parkway (1939) were opened for the exclusive use of automobiles. They influenced regional personal transportation, limiting the use of horse-drawn vehicles and later threatening trolleys and trains. Stables closed, and barns converted to garages. Blacksmiths vanished in the wake of automobile mechanics. Tire shops were essential for early automobiles, which were prone to flat tires. Shown here are two tire and mechanic shops. The above establishment, seen in 1911, stood at the corner of Third and Prospect Avenues, near the train depot. Seen at right in 1947 is a service station at the corner of Third Avenue and Second Street. It was replaced by the rear portion of a supermarket.

The local automobile repair shop seen above in 1935 was on Prospect Avenue near the train depot. In 1899, Dr. Thomas F. Goodwin introduced Mount Vernon to the first "horseless carriage." As he drove down Fourth Avenue or on his way to visit a patient, crowds gathered to see the automobile. Dr. George W. Thompson, Mount Vernon's first African American physician, came to the city in 1905. He was known for his shiny automobile (left), which he used to make house calls. In addition to doctors, local morticians were early owners of automobiles, turning their stables into garages. Funeral cars became a symbol of the modernization of their business practices.

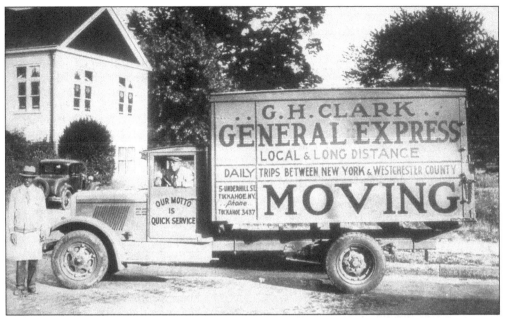

By 1940, railroad technology gradually gave way to growing popular and affordable personal modes of mechanical transportation—the more efficient and dependable automobiles and motorcycles. Ultimately, trains and trolley cars could not compete with the public's fascination with the idea of freedom of mobility. Cars, no longer luxuries, soon became necessities of business and family life. Above, in 1929, George H. Clark; Mount Vernon businessman and truck owner, poses on the left. Below, Paul Caramuto rides a motorbike on First Street in 1945.

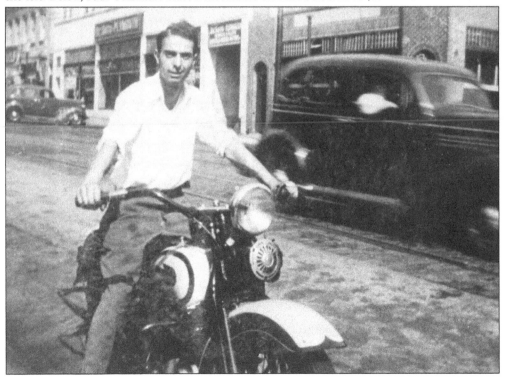

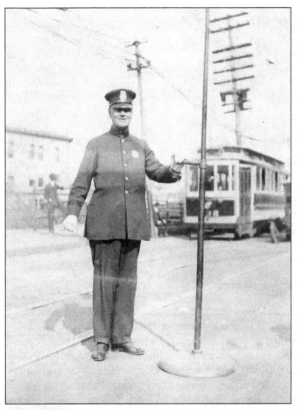

At left, police officer Clayton Van Weusen directs traffic at Fourth Avenue and First Street in 1926, before the installation of traffic signals. Cheap oil fueled the rapid expansion of increasingly reliable and affordable automobiles as personal transportation. Below, a filling station sign at Fifth Avenue and Third Street announces six gallons of gas for 95¢, a reminder of the nation's preeminence in oil production. The industry had a long-term effect on the local economy. By 1940, Eastchester Creek had become a primary automotive and home heating–oil distribution center for the entire Northeast. Railroads, elevated trains, and trolleys remained important methods of mass transit, but as the city's middle class continued to grow, so did its appetite for cars. (Below, courtesy of Paul Caramuto.)

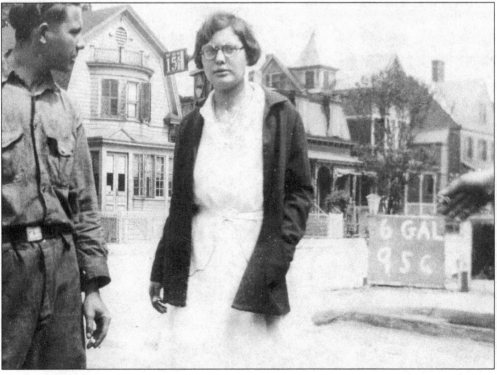

An 1896 government commission declared the Bronx River a polluted stream, a result of northern sewage passing by the western Mount Vernon border. This was also the case for the Hutchinson River. In 1906, the Bronx River Parkway Commission was established. Construction began in 1907, making it the earliest automobile-only highway to start construction. On November 5, 1925, the Westchester County portion of the Bronx River Parkway (right) opened. The total cost of the 16-mile project was $16.59 million. The rescue of the polluted stream and the subsequent bucolic drive along the parkway drew national attention. The development of the Fleetwood section of the city, shown below around 1944, was fostered by the construction of fashionable apartments, and this increased the use of automobiles. The bridge shown here connected city roads to White Plains, Yonkers, and New York City, as well as to Westchester towns and cities on Long Island Sound. (Both courtesy of WCHS.)

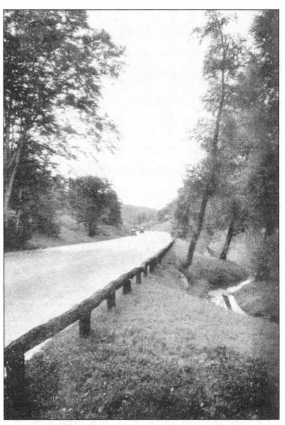

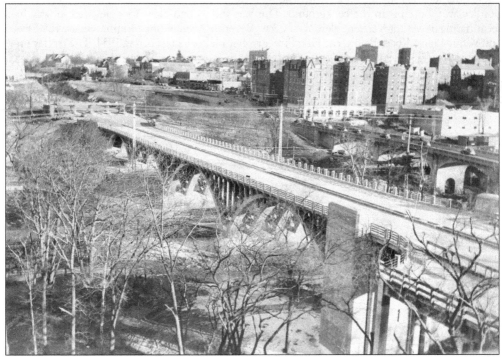

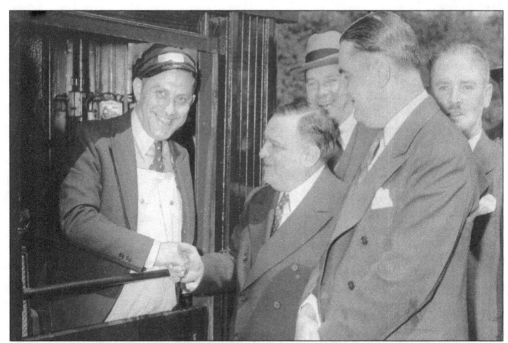

The New York, Westchester & Boston Railway Company, known to its riders as the Boston–Westchester, discontinued in 1935. It had three stations in Mount Vernon, including a trendy depot at Third Street and Fulton Avenue. Shown above is the May 15, 1941, opening of the elevated Lexington Avenue train line in New York City, which terminated at Dyre Avenue, on the border of Bronx County and Mount Vernon. In the photograph, New York City mayor Fiorello LaGuardia (center) shakes hands with the motorman after the first run. New Rochelle mayor Stanley W. Church is in the background. This was the second New York elevated subway line terminating at Mount Vernon. New York City's Seventh Avenue line terminated at 241st Street and White Plains Road. Below, the First Street trolley makes its last run in 1954. The trolley took passengers to the Seventh Avenue subway line.

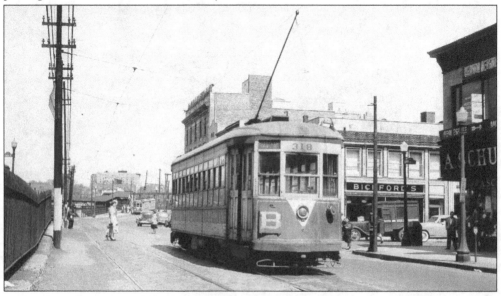

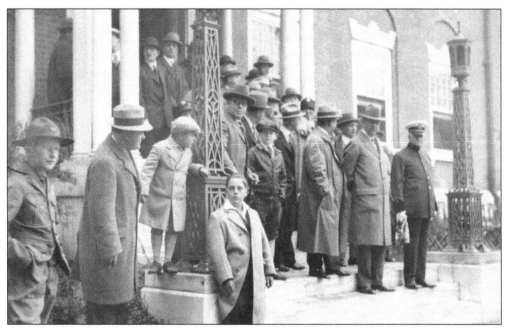

Above, officials prepare to formally move from the old city hall, located at the Lucas Building, at the northeast corner of Fiske Place and Gramatan Avenue, to the newly constructed building on Roosevelt Square. Among those standing in front of the police station are, from left to right, police commissioner George Atwell; Mayor James Burg, with his hands in his pockets; commissioner of public safety Mark Stiles; and police chief Michael Silverstein (far right). This ceremonial dedication and occupation of the new center of government took place in 1929. Below, Edward Patterson Jr. (center), born in Mount Vernon in 1905, was appointed in 1937 by Mayor Denton Pearsall (far right) as the first African American to work in city hall. He became the elevator operator. Mayor William Hussey appointed Patterson to the auxiliary police department in 1943, and he was named deputy sheriff in 1950.

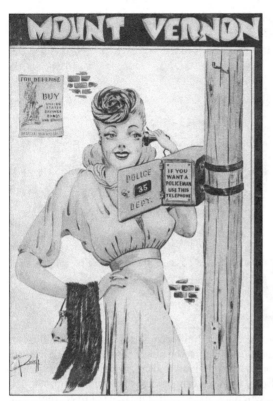

Shown at left is the cover of the 1942 Mount Vernon phone book. During World War II, telephones were posted throughout the city for police emergencies. Below is a 1948 fire emergency at the Loew's Theater on Stevens Avenue. The theater was across the street from city hall. In the 1980s, Mayor Ronald Blackwood built a public parking garage on the site.

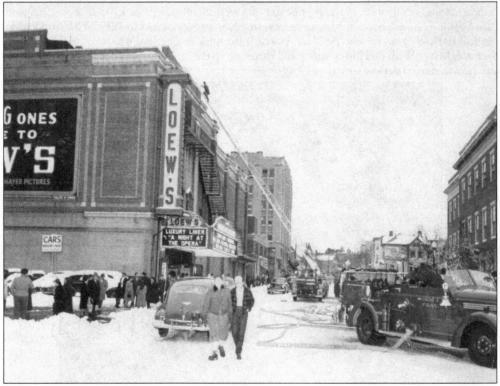

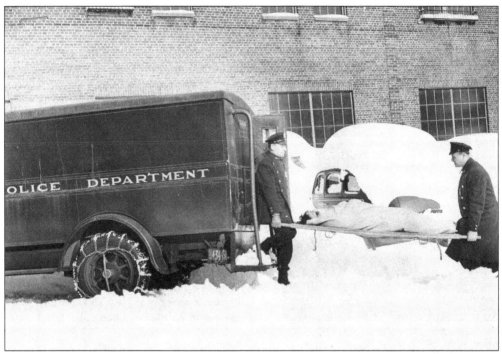

Police services were greatly improved with the purchase of trucks capable of responding to emergencies and transporting sick and injured persons to the hospital. Above is a photograph of a 1946 response. Below is the 1963 Memorial Day parade, led by Nasby Wynn (right), former high school football star, US Air Force pilot, and World War II veteran. In 1946, Mayor William Hussey appointed Wynn to the police force, making him the city's first African American police officer.

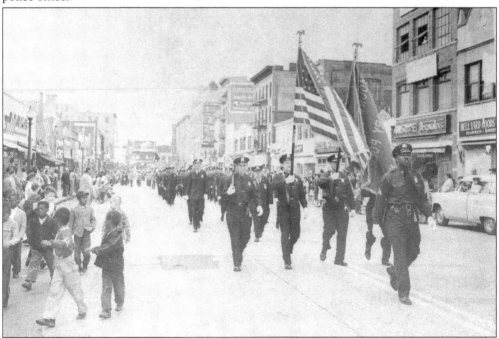

In 1953, Mount Vernon celebrated its centennial. It was a fast-changing small city supported by two commuter railroad lines. It was also a divided city. Its greatest change was its ethnic diversity. The north was predominately white, with an emerging Italian middle class. South of the tracks was a growing African American population. Joseph Vaccarella (left) was the city's first Italian mayor. Shown below are two young men selected to be "Mayors for the Day," as representatives for the Northside and Southside Boys' Clubs. At left is Ralph Cenna from the Northside Boys' Club, and seated is the Southside's William "Billy" Thomas. Few believed that an African American would ever become Mount Vernon's mayor, but the seed was planted. In 1985, Roland Blackwood, an African American with Jamaican roots, became mayor. He was the first person of color to hold such a position in New York. (Below, courtesy of the William Thomas collection.)

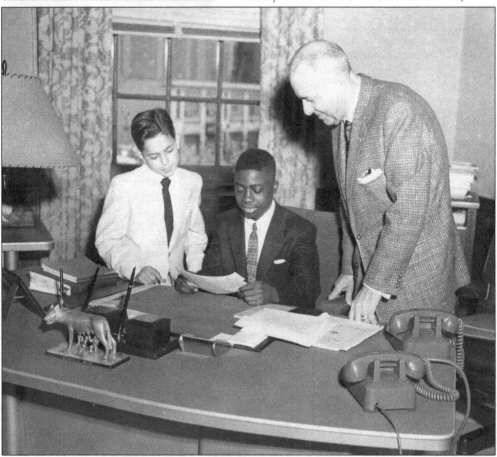

Three

REDEFINING THE
FOUR SQUARE

In the 1890s, Southern Italian families settled and redefined the city. In 1891, Guiseppe Reitano opened a fruit and candy store on North Fourth Avenue. He joined James Oprandi, A. Pittari, Joseph Nardozzi, Phillip Scarpino, Gracinto Genesse, Augustine Franko, V. Covinas, J. DeMarco, Nicola Yanantuono, Frank Nordone, the Carideos, Cardillos, Petrillos, Pirros, and others.

Between 1893 and 1895, an additional 300 Italians arrived to work on the railroad cut. They were paid $1.05 for a 10-hour day; the wage was later reduced to 90¢. The Italians protested and were persecuted. Michael "Red" Annecharico, their leader, demanded justice, and he, too, was arrested. They lived east and west of Gramatan Avenue, on Mount Vernon Avenue near Bond Street, and along West Third Street. Their ethnicity and poverty created the proverbial "other side of the tracks." Meanwhile, Southern African Americans arrived and joined the Italians looking for work.

Mount Vernon offered Italians public education and opportunities to prosper. The hard-working immigrants raised families, spoke regional dialects, and honored their patron saints and feast days. In 1910, there were 2,670 foreign-born Italians; a decade later, the number reached 3,348, out of 17,000 residents. In 1917, they did not hold public office or serve as city workers, but their children attended city schools, went on to college and into the professions, started businesses, and entered politics. They organized the Italian Civic Association, devoted to their cultural and political advancement. In 1919, Clement Carnevale became the first Italian American elected to the school board. By 1920, Italians represented a quarter of the city's population. In 1928, Eugene J. Orsenigo was elected to the first of a pair of five-year terms on the board. During the Great Depression, Orsenigo created jobs by initiating a federally funded multimillion-dollar school construction program.

By 1953, the city's total population had grown to nearly 75,000. In the midst of the changes, Mount Vernon hosted its Centennial Centurama. It was different than previous heritage celebrations. There were new political personalities responsible for the city's history. The event signaled the reshaping of the city into a reflection of the increasingly prosperous Italian and African American communities. The celebration was led by Mayor Joseph P. Vaccarella; Joseph Reitano, president of the Common Council; Alfred Franko, city historian; and other distinguished Italian Americans. Eileen Petrillo, the Centennial Queen, was a daughter of an enterprising 1890s immigrant family. After 100 years, the older southside and westside houses were in disrepair. High-rise apartments were built on the north and south sides. City officials continued to promote Mount Vernon's reputation as "The City of Happy Homes."

Above is a 1914 Washington School class. Shown are, in no particular order, (first row) Edna French, Elsie Von Garrett, Clara Nesbit, Lucy Scheels, Mamie Kessler, Florence Legget, Esther Carrol, Marion Earl, Gertrude Vinton, Tillie Kessler, Alma Hoerst, and Hattie Von Garrett; (second row) Libbie Goodwin, Winifred Warner, Alice Fleichman, Rosie Hickey, Maggie Matern, Julia Weber, Grace Pank, Mamie Wilkey, Elsie Reid, May Havey, Annie Walker, and unidentified; (third row) George Bernara, David Emmeluth, Willie Pirus, Everett Sheridan, Henry VanEss, Willie Murphy, Willie Wachkau, Allen Marsh, unidentified, John Gagg, Joseph Ryan, Theodore Crolly, Harry Bonn, Herbert Kerr, and ? Slagel. Nathan Hale School was three block south on Sixth Avenue. Shown below is Henry Small's 1961 sixth-grade graduating class. These students entered Washington Junior High School that fall. Both were southside neighborhood schools. In the 47 years separating these two photographs, the increased ethnic diversity within the community and school is evident.

An African Methodist Episcopal Zion church was established and dedicated on North Fifth Avenue in 1868, but there is no question that Grace Baptist Church, established in 1888, was the city's African American "mother Church" in terms of influence and historical importance. It spawned Macedonia Baptist and a host of local clergymen. Rev. Granville Hunt pastored the church in 1896, and his descendants remain fixtures in civic life. In 1931, Rev. Joshua Levister was the first African American to run for the school board. His brother Benjamin Levister was the driving force in establishing the housing authority and the building of Levister Towers. He fought for the desegregation of local public accommodations. Richard Levister, a noted musician, founded 1950s and 1960s rock 'n' roll bands. These photographs show a 1940s wedding officiated by Grace's Rev. George C. Thomas. The church had nearly 350 congregants. Today, under the leadership of Rev. Franklyn W. Richardson, it has grown to 3,000 members.

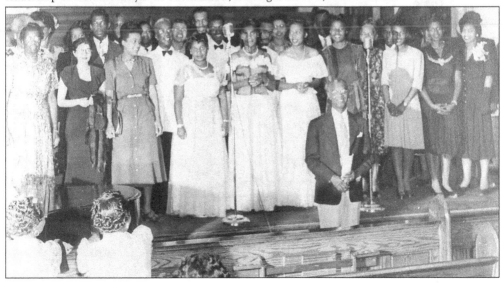

No one could forget the John and Anna Branca family, shown above in 1950. They lived near Sandford Boulevard and Ninth Avenue. Among their 17 children were Florence, Helen, Margaret, Rosemary, Antoinette, Annunziata, Anna, Julius, Edward, John, Paul, Al, and Ralph. On June 6, 1944, Ralph Branca, an 18-year-old Davis High School pitcher, signed a contract with the Brooklyn Dodgers. He is seen in the photograph below, standing at far right. From 1944 to 1956, he won 88 games and lost 68. In 1947, he won 21 games and lost 12. At the age of 21, Branca was a starting pitcher in the 1947 World Series. A teammate of Jackie Robinson and other Dodger greats, Branca is best known for his 1951 pitch to Bobby Thomson, who hit a home run to win the National League pennant for the New York Giants. Known as the "shot heard 'round the world," the home run remains one of the most dramatic moments in sports history.

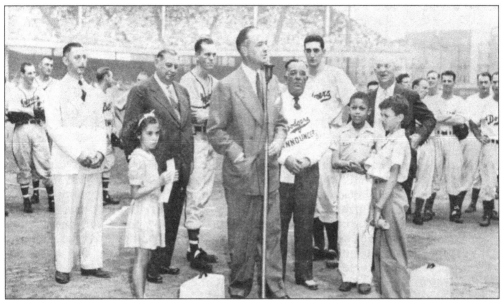

On August 13, 1947, Mount Vernon honored Ralph Branca and Anton "Andy" Karl at Ebbets Field (above). Branca was the first Brooklyn Dodgers pitcher to win 21 games. Karl was a veteran big-league relief pitcher for the Braves, Red Sox, and Phillies. Standing in the rear are, from left to right, city historian Al Franko, Mayor William Hussey, Anton Karl, and Ralph Branca. Nearly 2,000 proud Mount Vernonites joined 31,000 New York baseball fans to honor these great pitchers. The Ciarcia family is seen below in 1934. From left to right are (first row) James, Alfred, John Jr., Mary, Howard, and Arthur Ciarcia; (second row) Angelo, John (father), Mary (mother), and Eva; (third row) Dorothy, Irene, Marion, Ella, and Margaret. (Below, courtesy of Arthur Ciarcia.)

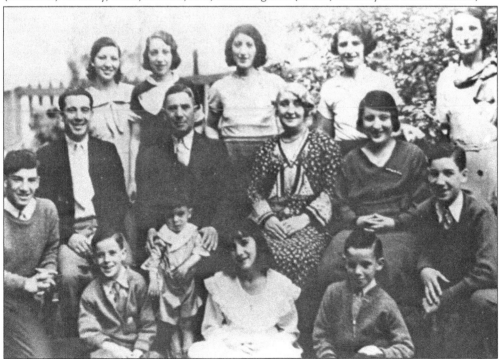

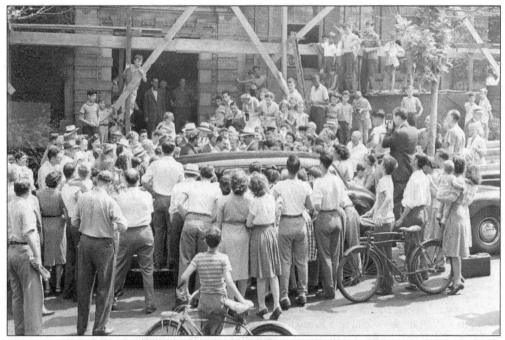

Above is a crowd gathered around Mayor William Hussey's car as he arrives at the 1949 ceremony for the demolition of the previous northside school and the construction of a new one. At left is a photograph of Fourth Avenue's 1957 July Sales Week. During this event, shopkeepers placed items on the sidewalks for quick sales. The *Daily Argus* ran advertisements for special bargains. Pedestrians strolled the two blocks, patronizing their favorite stores. A summer trip to "The Avenue" was incomplete without purchasing a treat at the ice-cream parlors, dining at the pizzerias, and, of course, eating a Chrystal's hot dog.

At right, Minn Barrish and James Gleason pose at the 1999 Fourth of July ceremony at St. Paul's Church National Historic Site. For over a century, this patriotic celebration has hosted patriotic speeches, marching bands, and a reading of the Declaration of Independence. It remains an occasion for flag-waving and for politicians to shake hands and kiss babies. Barrish was a loyal organizer of the event. For nearly 70 years, the Barrishes were successful downtown merchants. James Gleason was the fire commissioner and an active member of the Democratic Party. Below is Samuel Nelson's headstone. In 1826, Nelson, a fugitive slave, found a home and a wife on the old Boston Post Road near St. Paul's. Benjamin and Rebecca Turner, freed slaves and landowners, were his in-laws. For 30 years, Nelson dug graves in the cemetery. The Turner-Nelson story is one of the interesting historical items featured on the Fourth of July St. Paul's cemetery walking tour. (Right, photograph by Dr. Larry H. Spruill; below, courtesy of St. Paul's Church National Historical Site.)

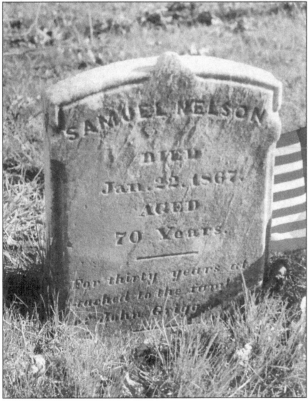

The 1953 Centennial Centurama Miss Mount Vernon beauty pageant featured 75 young ladies competing for the crown. Sales of advanced tickets to the Centurama and votes received by fan mail determined the winner. Eileen Petrillo (left) was the first-prize winner. Her ladies of the court were Peggy Vagats, Marietta DeVito, Marilyn DiLeto, Geraldine Ferrara, Maria Grosso, Anita Lans, Susan Schlossberg, Lillian Scalzo, Barbara Bremmer, Emma Jean Chavers, and Norma B. Mele. Chavers (second from right) was the African American community's proud participant in the historic pageant. She is a retired Mount Vernon school administrator. (Below, courtesy of Emma Jean Chavers.)

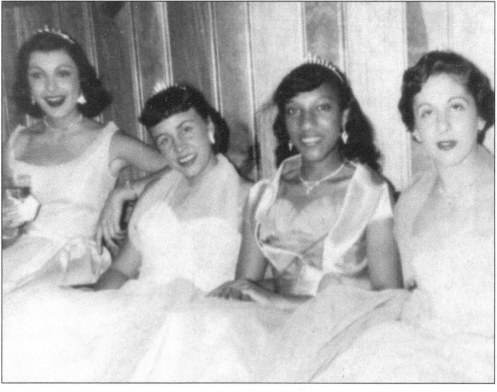

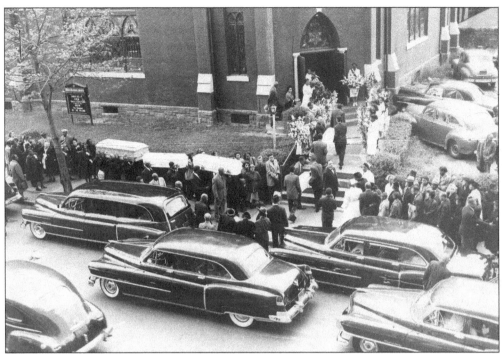

For the 1953 Centennial Centurama parade, 100,000 people lined the route, and the city displayed its modern fire, police, and other public services. In addition, fire and police departments from across the metropolitan area joined in the occasion. During this grand march through the city, tragedy struck. A fire broke out at the Brown family home, on Edison Avenue near Eastchester Creek, killing five people. Above, the five caskets are brought into Grace Baptist Church for the funeral. The photograph below, taken on October 30, 1953, shows the senior officers of the 20th graduating class of Edison Technical High School. They are, from left to right, (first row) Owens Biermann, principal; Robert Rowson, president; Pasquale Tedesco, advisor; (second row) Augustine Yosue, treasurer; Jean Vilano, secretary; and Donald Hinspeter, vice president.

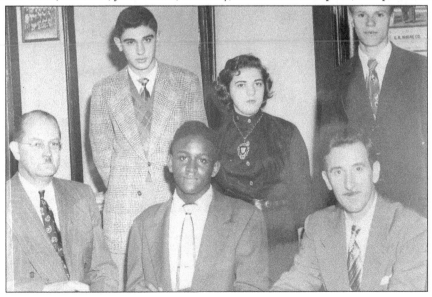

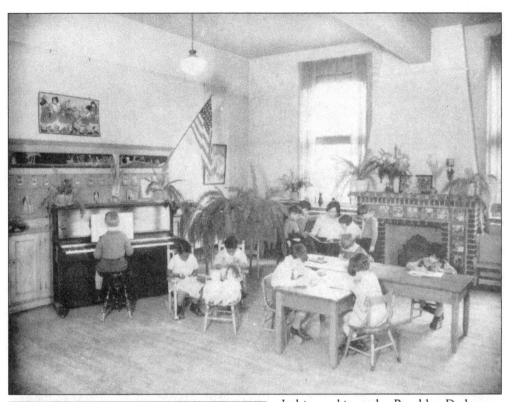

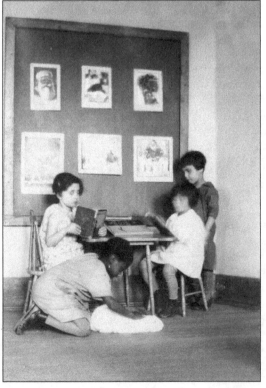

In his autobiography, Brooklyn Dodgers great Ralph Branca proudly noted the interracial character of his southside neighborhood. He also recorded the different expectations an educator had for him because of his Italian heritage. It did not diminish his love for Mount Vernon, but instead inspired him to excel in everything he set out to do. African American children faced and overcame similar challenges. Shown here are two Depression-era integrated classrooms at Nathan Hale Elementary. In these two images, the white students read, write, create art, and play the piano. The African American children clean the floor, sew, and play with dolls. The photograph above was taken in 1934, and the photograph at left in 1936.

At right is a 1942 NAACP broadside for a meeting at Nathan Hale School about the war in Europe against fascism and the battle at home against racism. During World War II, African American soldiers fought and gave their lives. They developed the symbol of the "Double V," calling for a dual victory. They predicted victory over Nazism and fascism abroad and a domestic victory against segregation and inequality. This meeting touched on issues related to the war against racism and intolerance. The 1951 photograph below shows, from left to right, James Avery, Benjamin Anderson, Dr. William Randolph, and Eleanor Thomas. They were social and political Republican reformers on housing, poverty, education, and racial justice issues.

N.A.A.C.P.

PRESENTS

Dr. Channing H. Tobias

National Secretary of Y. M. C. A. Councils and a Member of the Board of Dir·ctors of the NATIONAL ASSOCIATION For The ADVANCEMENT of COLORED PEOPLE.

WHO WILL SPEAK ON

"A WAR WITHIN A WAR"

NATHAN HALE SCHOOL AUDITORIUM
SOUTH SIXTH AVENUE, NEAR SANDFORD BOULEVARD
MOUNT VERNON, N. Y.

FRIDAY EVG., JUNE 16

AT 8:30 P. M. SHARP

ADDED ATTRACTION
THE FORDHAM CHORAL GROUPS

This Meeting Closes Our Membership Drive
JOIN NOW

Admission FREE Admission FREE

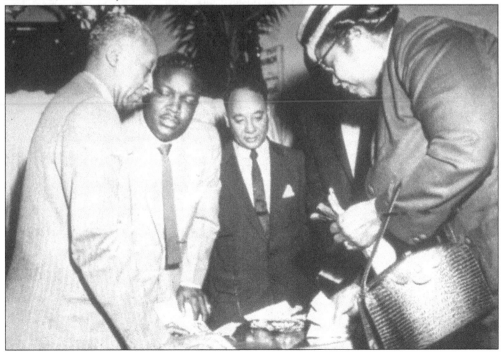

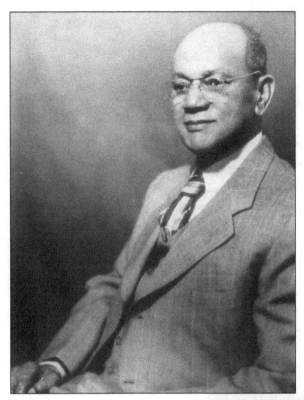

Dr. George Thompson (left) was the first African American physician to practice in Mount Vernon. He graduated from Columbia University and came to the city in 1905. A year later, he held a meeting of the Colored Citizens League at his home at 150 South Eighth Avenue, where he discussed the "unsanitary living conditions for Negroes." Dr. Thompson was the second African American physician admitted to practice at Mount Vernon Hospital. Dr. Clarence Q. Pair (below) graduated from Howard University Medical College in 1926. A year later, he opened a practice in the city. In 1929, he became a founder of the local NAACP. His office was on the southeast corner of Sixth Avenue and East Third Street. In 1945, he was appointed the first African American staff doctor at Mount Vernon Hospital.

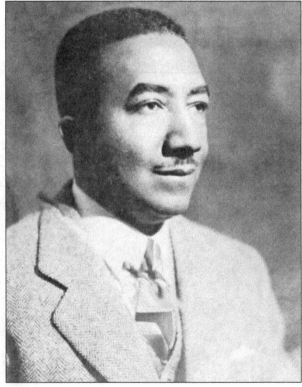

Dr. George Edmund Haynes (right) was the cofounder and first executive director of the National Urban League, founded in 1910. He lived in Mount Vernon in his later years. Haynes received a PhD in sociology from Columbia University. From 1918 to 1921, he served as director of the Division of Negro Economics in the US Department of Labor, thus becoming the first African American to serve in a federal subcabinet post. He was also a founding regent of the New York State Education Department. Edward Tucker (below) was the son of William Tucker Sr., who came to Mount Vernon in the 1880s. William Tucker was an early-20th-century "dyed-in-the-wool Democrat" at a time when every "self-respecting" African American considered themselves a Frederick Douglass, Harriet Tubman, or Crispus Attucks Republican. The party was associated with Abraham Lincoln and emancipation, but that did not matter to the Tuckers. The family remains active in city Democratic politics.

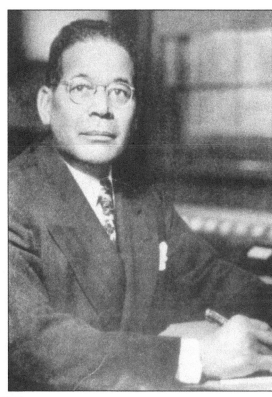

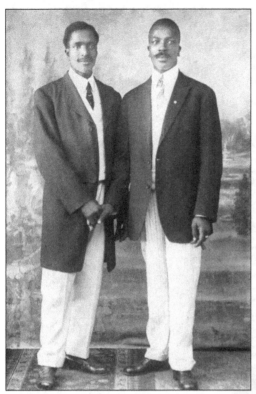

Shown at left are James M. (left) and Walter Bridges. They migrated to the city in 1894. In 1909, the brothers established Bridges Real Estate. James's son Lawrence operated the firm from the prestigious First National Bank building, at 22 West First Street. Another brother, Thomas Bridges, was an artist and a founding member of the local NAACP. Ludacris (Chris Bridges), one of the nation's premier hip-hop artists, is the son of the late Wayne Bridges of South Sixth Avenue. The Bridges family has a successful history in the city. Below is the McCoy family, photographed in August 1923. Shown with Mr. and Mrs. Howard L. McCoy Sr. are, from left to right, friend of the family Catherine Harris, and the McCoy children, Blanche, Thornton, and Howard L. Jr. In 1991, after 43 years, Howard Jr. retired as chief of police for the Mount Vernon force. Catherine Harris was the first African American student president of Washington Junior High School.

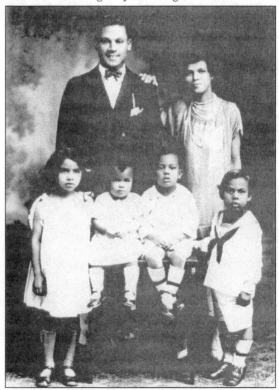

Rev. Dr. James R. White (right) was the pastor of Greater Centennial African Methodist Episcopal Zion Church (AMEZ) during the Great Depression. Reverend White stabilized and nurtured the church until it became a pillar in the southwest sector of the city. He made ambitious plans to build a new church for the growing congregation. An activist, Reverend White unsuccessfully ran for the Mount Vernon school board in 1932. Rev. Rinico Nelson (below) was pastor of Macedonia Baptist Church from 1917 to 1957. After Macedonia split from Grace Baptist, it floundered until Reverend Nelson became pastor. He was active in growing Macedonia from, as he said, "an acorn to an oak tree."

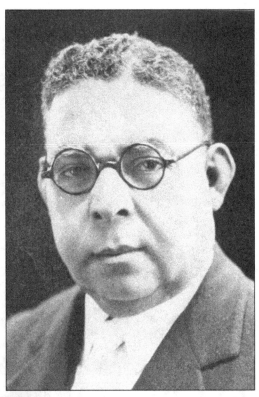

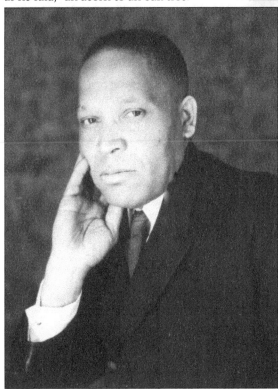

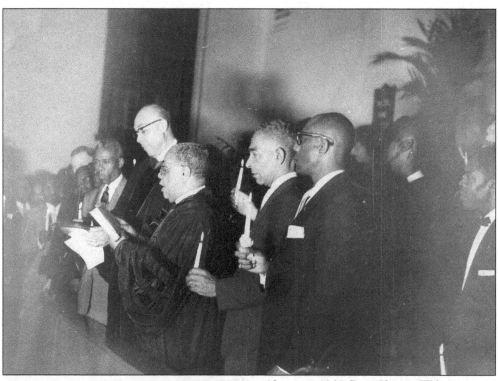

Above, in 1960, Rev. Clinton Wilcox (the tall gentleman with glasses) and church officials burn the last mortgage payment for the new church. At left is a 1947 poster from the newly appointed pastor of Centennial Church for a rally supporting the emerging Southern civil rights movement. Reverend Wilcox formerly pastored in Montgomery, Alabama, and was a contemporary of Rev. Vernon Johns, the fiery pastor of Montgomery's Dexter Avenue Baptist Church. In 1955, Rev. Dr. Martin Luther King Jr. became the youthful pastor and leader of the church and the historic Montgomery bus boycott. Reverend Wilcox did not forget his Alabama clerical roots.

A city with two distinct sides of the railroad tracks was destined to create institutions that reflected that social and racial reality. Segregation was a factor in Mount Vernon. There was a YMCA for white children. On the right is a 1939 flyer for a benefit concert for the Mount Vernon Colored YMCA. It closed in 1954, the year the Supreme Court declared the "separate but equal" doctrine unconstitutional. The photograph below shows a 1947 adult night-school class at Washington Junior High School. Newcomers with very little education and skills took advantage of Mount Vernon's commitment to continuing education. In 1938, Cecil H. Parker held a master's degree from New York University and worked part-time at the night school. In 1942, she integrated the district's full-time faculty and became its first African American teacher.

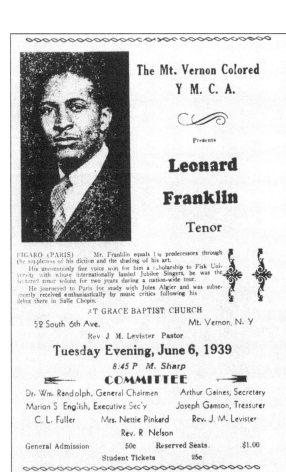

The Mt. Vernon Colored
Y M. C. A.

Presents

Leonard Franklin

Tenor

FIGARO (PARIS) Mr. Franklin equals his predecessors through the simpleness of his diction and the shading of his art.

His uncommonly fine voice won for him a scholarship to Fisk University with whose internationally lauded Jubilee Singers, he was the featured tenor soloist for two years during a nation-wide tour.

He journeyed to Paris for study with Jules Algier and was subsequently received enthusiastically by music critics following his debut there in Salle Chopin.

AT GRACE BAPTIST CHURCH

52 South 6th Ave. Mt. Vernon, N. Y

Rev J M. Levister Pastor

Tuesday Evening, June 6, 1939

8:45 P M. Sharp

COMMITTEE

Dr. Wm. Randolph, General Chairmen Arthur Gaines, Secretary

Marion S English, Executive Sec'y Joseph Gamson, Treasurer

C. L. Fuller Mrs. Nettie Pinkard Rev. J. M. Levister

Rev. R Nelson

General Admission 50c Reserved Seats. $1.00

Student Tickets 25c

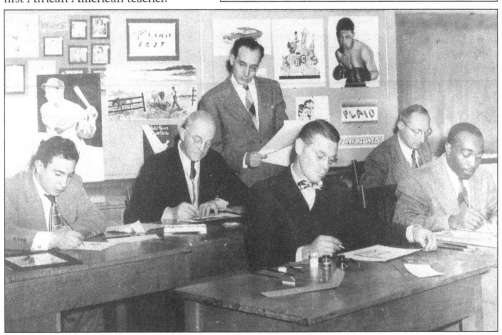

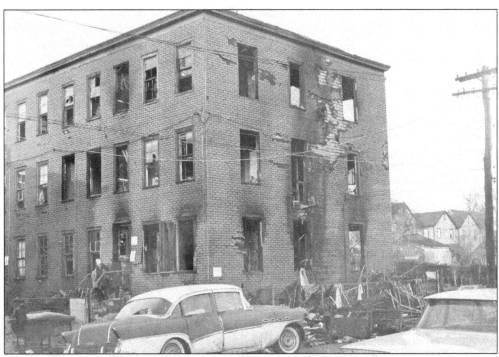

Above, a 1965 fire burned the last of the ABC Flats on South Eighth Avenue. These were the cold-water flats that housed early Italian Americans and African Americans seeking employment and opportunity for their families. Edward Williams, the first African American male schoolteacher and, later, principal at Robert Fulton School, was born in these buildings in 1905. Referring to the flats, a newspaper headline once read, "Mount Vernon a 'City of Homes' or a 'City of Hovels.'" The photograph below, taken around 1950 looking south from Eighth Avenue and Third Street, shows the newly constructed Benjamin Levister Towers housing complex, at 215 South Ninth Avenue. These 10-story, low-to-moderate-income apartment buildings were erected as a response to the primitive housing conditions at the Flats and other neighborhood slums.

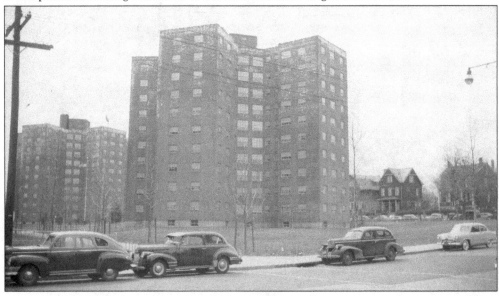

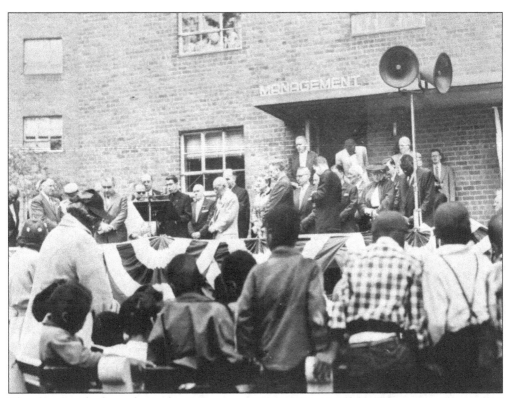

The photograph above shows the 1949
opening dedication of the Levister
Towers housing complex. The ceremony
took place at the management office on
Eastchester Lane, at the rear of the 240
South Seventh Avenue building. The
initial goal for the low-income housing
complex was affordable apartments for
returning veterans and the working poor.
In the first decade, the high-rise buildings
achieved racial integration. For decades,
Levister Towers successfully transitioned
hundreds of families and their children
into the middle class. Eunice Alston
(right), a former Levister Towers resident,
lived at 215 South Ninth Avenue. She
was a beloved community activist.
In 1975, she was the first resident of
Levister Towers to organize an interracial
coalition, winning a five-year seat on the
Mount Vernon School Board. Alston
mentored hundreds of children living in
"the projects" to set their sights beyond
the south side of the railroad tracks.

Under the leadership of Dr. William Holmes, superintendent of schools from 1913 to 1940, Mount Vernon was a nationally recognized leader in school-based health services. In the photograph above, taken at Nathan Hale Elementary School on October 7, 1949, (from left to right) Helen Appel, Ursula Pastore, nurse teacher Helen Burton, and Angela Lillo perform the annual weight and height measurements of students. Below, a Washington Junior High School band rehearsal takes place in Wood Auditorium on October 30, 1953. The singers are, from left to right, Othis Thornhill, Barbara Hayes, Cynthia Miller, and Robert Scott. Lorenza Winn plays the flute, Ronald Innecken plays the trumpet, and Robert Evans is at the piano.

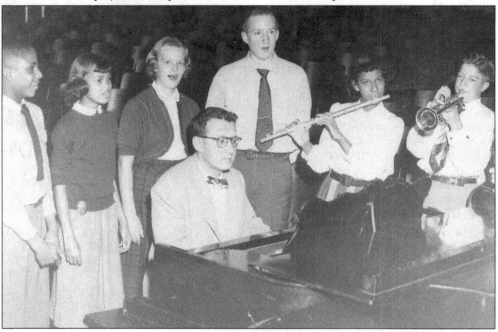

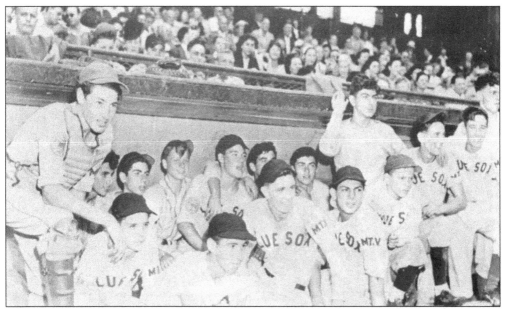

The photograph above shows the Mount Vernon Blue Sox at Ebbets Field. They are, from left to right, (first row) Bruce Johnson, Gerry Bode, Dave Binhak, Herb Sevens, Marvin Woolf, and Archie Witz (batboy); (second row) Phil Sylvestre, Leo Gilberg, Bob Hrubesh, Harry Amar, Bob Bruce, Dan Pearson, Tony Caputo, Tony Freed, Lou Healy, and Bob Gottesman. Not pictured are Bill McCabe, Larry Krell, Tom Waters, Peter Berland, and team manager Bill Real. On hot summer days in 1950s suburban Mount Vernon, the roving Good Humor trucks (below) rang their bells and sold the gathered children ice cream. It was a valued job for workers seeking to support their families. Carlton Holder became Mount Vernon's first African American Good Humor driver and salesman. The trucks are lined up for inspection on Gramatan Avenue, next to Hartley Park. (Above, courtesy of Tony Caputo.)

At left is a 1914 photograph of Horton's Ice Cream Parlor in the Goodie Shop, at 22 East First Street. Cobblestone streets and trolley lines were prominent on the roadway. The towering brick First National Bank, later known as the Chemical Bank Building (now Chase Bank), occupies the space. Below is a rare 1953 photograph of Mount Vernon's Carvel Ice Cream Parlor, at the southeast corner of Sandford Boulevard and South Columbus Avenue. The franchised business, founded in Yonkers, became known as the nation's favorite soft ice cream. This store was replaced by the Colonial Place strip mall, which includes the current Ice Cream Factory.

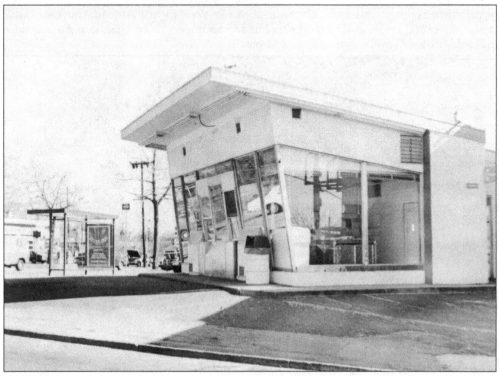

In 1947, Fourth Avenue was a busy, two-block downtown strip with bustling pedestrian traffic, as seen above. Today, it is hard to imagine how the narrow, one-way street ever accommodated two-way automobile traffic. The Department of Public Works truck on the left is picking up commercial trash. Today, driving and parking on "The Avenue" remains a transportation and shopping challenge. During the Cold War, the threat of nuclear attack spawned drills in schools and the construction of bomb shelters. The image below shows the completion of a civil defense drill in 1954. It was taken at First Street and Fourth Avenue. At right, on the second floor, is the Arthur Murray Dance Studio. As a Mount Vernon teenager, Dick Clark of *American Bandstand* fame recalled taking dance lessons in the upper room.

The 1958 photograph above looks north on South Seventh Avenue near Third Street. In the 1960s, this block was the heart of the African American community. The buildings were torn down and replaced by the Griffith and Valentino Firehouse, named after the first two native sons killed in Vietnam, and the Grace Senior Citizens Housing Complex. The 1970 photograph below looks east on West Third Street from Eighth Avenue. If Fourth Avenue was known as "The Avenue," West Third Street was known as "The Block." Upon hearing those terms, people unmistakably knew what thoroughfares were being discussed. Even today, "Third Street" refers to the stereotypical "South Side." The buildings were torn down and replaced with a low-rise housing development known as Ebony Gardens. (Above, courtesy of the *Westchester Observer* collection.)

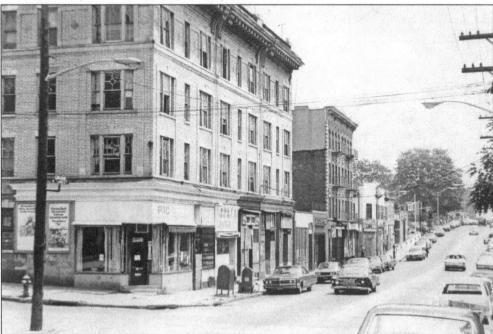

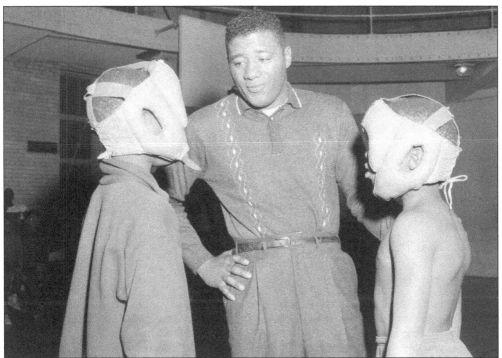

At age 21, Floyd Patterson (above), a professional boxer and Mount Vernon resident, became the youngest man to win the world heavyweight title, earning the distinction as the undisputed champion. He was also the first heavyweight to regain the title. He had a record of 55 wins, 8 losses, and 1 draw, with 40 wins by knockout. As a middleweight, Patterson won the 1952 Olympic gold medal. On June 20, 1960, Patterson knocked out Ingemar Johansson in the fifth round of their rematch to become the first boxer in history to regain the undisputed world heavyweight title. In the photograph above, Patterson works with young people at the Mount Vernon YMCA. In 1960, Mayor Joseph Vaccarella, a former Olympic and professional boxer, welcomed Patterson home with a Fourth Avenue parade (below).

There were two Mount Vernon Boys' Clubs. Pictured above is the Southside unit, on Seventh Avenue near Third Street. The conditions were primitive and inadequate for the growing number of impoverished African American boys living in the adjoining slums and in the newly constructed, low-income Benjamin Levister Towers, located between Seventh and Ninth Avenues and bordered by Third and Fourth Streets. This was the heart of the southside community and the most densely populated and disadvantaged federal census track in Westchester. Below, boys practice the long jump in the gym around 1958.

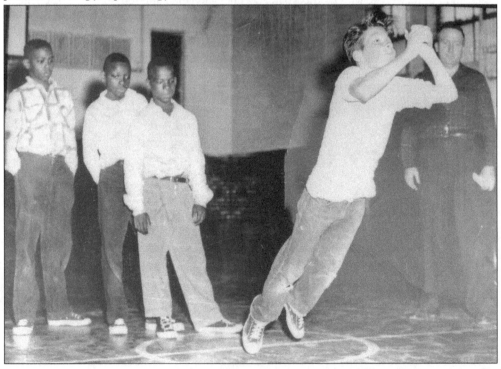

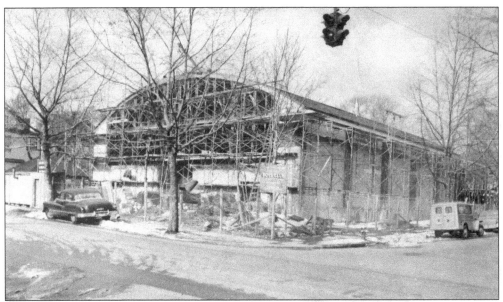

Above, construction is underway in 1959 on the new Southside Boys' Club, at the northwest corner of South Sixth Avenue and Fifth Street. It became a safe haven for thousands of young men growing up in the city. Parents were never worried about their children as long as they were at "the Club." In the mid-1960s, Lenn Washington sent her son Denzel there. He is now a national spokesman for the Boys & Girls Clubs of America. Posing below in the new club are, from left to right, Arthur Overton, unidentified, unidentified, Danny Cartwright, David Edwards, and James Clayton. Young men became productive citizens under the leadership of club directors Richard Caputo, Vick Rapone, William "Billy" Thomas, and James Tuitt.

At left, Martin and Bella Abzug and their family pose as proud Mount Vernonites. In 1952, the Abzugs chose to move from New York City to Mount Vernon because they wanted to raise their daughters in an interracial community and school. The Dixons (below) and Abzugs were neighbors on East Fifth Street between Fulton and Columbus Avenues. They organized and resisted blockbusting real estate brokers. The Abzugs moved in 1967 when Bella ran for Congress in New York. The Dixons had moved to Mount Vernon when Rev. Richard Dixon became pastor of Macedonia Baptist Church. The church purchased a parsonage in Vernon Heights, a formerly white, upper-middle-class neighborhood. A close friend of Rev. Dr. Martin Luther King Jr., Reverend Dixon organized the Westchester Christian Leadership Conference and sent a large delegation to the famous 1963 March on Washington. He was among the few invited to join Dr. King's entourage to Oslo, Norway, when King received the 1964 Nobel Peace Prize.

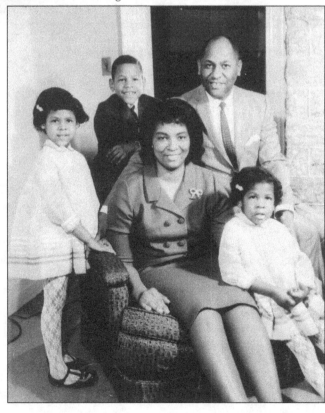

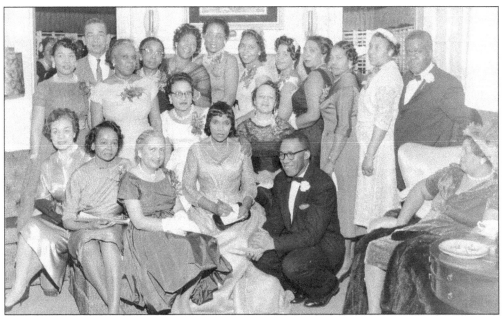

The photograph above shows a reception in 1959 of the black upper and middle classes at the home of Rev. Richard and Ernestine Dixon. The special guest was one of the most celebrated singers of the 20th century and a civil rights icon, Marian Anderson. She gave a memorable concert, helping to launch Reverend Dixon's five-decade tenure at the Macedonia Baptist Church. On November 1, 1978, the playground across the street from 240 South Seventh Avenue, was renamed Edward Williams Park. Williams (below, second from right) exemplified the American Dream, rising from poverty in the 1930s via high school and college athletics and returning home to become a beloved educator. Though born in 1905 in a cold-water flat, he purchased a home in Vernon Heights near the Abzugs and Dixons. He loved the city and gave heritage tours. To his right are his son and daughter, Joseph and Candy Williams.

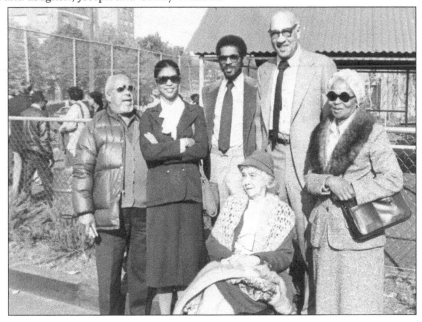

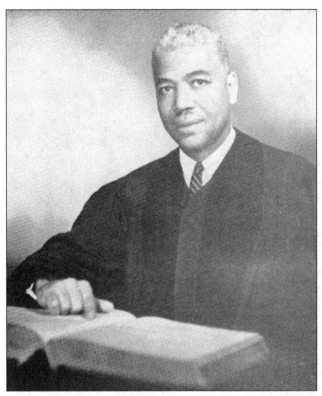

As white denominational churches abandoned the city's south side, they left behind spacious and ornate houses of worship. In 1954, Rev. Henry Grant Jones (left) became pastor of Unity Baptist Church, located at the northeast corner of Fifth Avenue and Fifth Street. He later moved his growing congregation into the former First Baptist Church. Shown below in 1947, the church, at the southeast corner of Second Avenue and Second Street, became the new Unity Baptist Church. Today, Unity Baptist proudly displays its signature marquee, "God Is Love." (Left, courtesy of Mattie Little.)

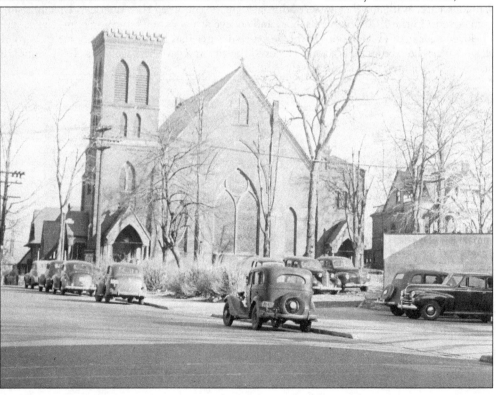

In the 1960s, an epidemic of drug addiction slowly found an expanding foothold in the city's south side. Generations of young people lost their hopes for upward mobility to the destructive drug plague. Many young persons lost their lives to death or prison. Dr. Ida Jiggets, seen at center in the photograph above, and the Mount Vernon Narcotics Council established innovative counseling and treatment programs. Her methods and practices became a statewide model for addressing drug addiction. Below, five new Mount Vernon firemen are sworn in on January 26, 1980. Shown are, from left to right, fire commissioner Joseph Hammond, Edmund Wiley Jr., Vincent Bartoline, Ronald Sanders, Al Everett, and unidentified. They were the first to be inducted in several years. Everett became the fire chief in the 1990s and was later elected to the school board. Sanders grew up in Levister Towers and was tragically killed in a sporting accident.

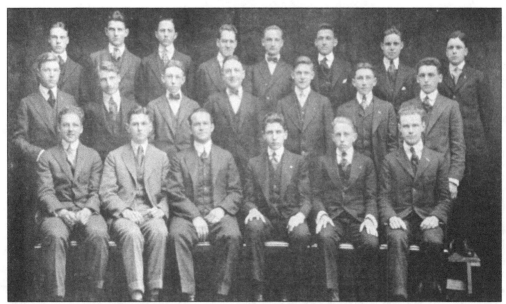

Shown above is the 1917 Mount Vernon High School Congress. Each young man was expected to become a leader of industry, commerce, arts and literature, law, or science. One of America's greatest essayists and writers, E.B. White, is in the second row, third from left. The Collegionaires (below) was a social club at Davis and Edison High Schools for upwardly mobile African American men. The club was an illustration of the changes taking place in the city. Seen here in 1960 are, from left to right, (first row) Ronnie Law, Johnny Patterson, Charles White, Robert Hawkins, Danny Johnson, and Ronald Henderson; (second row) Walter Johnson, Lenny Griffin, Lucious Kelly, Claude Nelson, Robert Blount, William Thomas, and Steve Mitchell. All but four of these men grew up in Levister Towers, and each attended college. They were transitioning into the middle class and adulthood during the civil rights era (1955–1968).

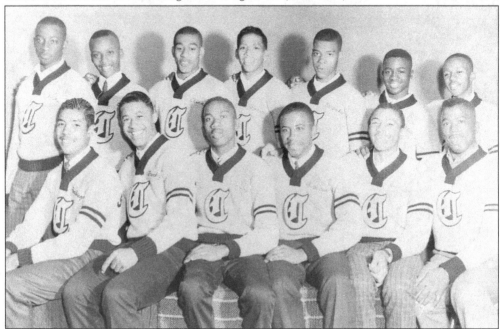

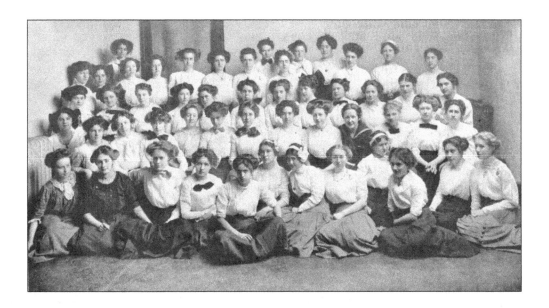

The 1913–1914 Mount Vernon High School chorus is shown above. There are no men, nor students of color, in the ensemble. There were few if any Italians in this extracurricular activity. Pictured below is the 1988 Mount Vernon High School choir. It included young men and is entirely African American. On April 9, 1988, it performed a sensational live recording, "Just Believe," in the auditorium with the late Grammy Award nominee Rev. Timothy Wright. They toured the Northeast and the Caribbean. These two photographs illustrate the city's dramatic demographic shift toward an African American majority by the close of the 20th century. (Below, photograph by William L. Ballinger; courtesy of Atlanta International Records.)

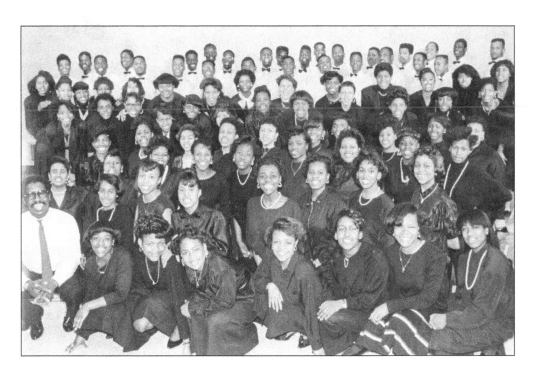

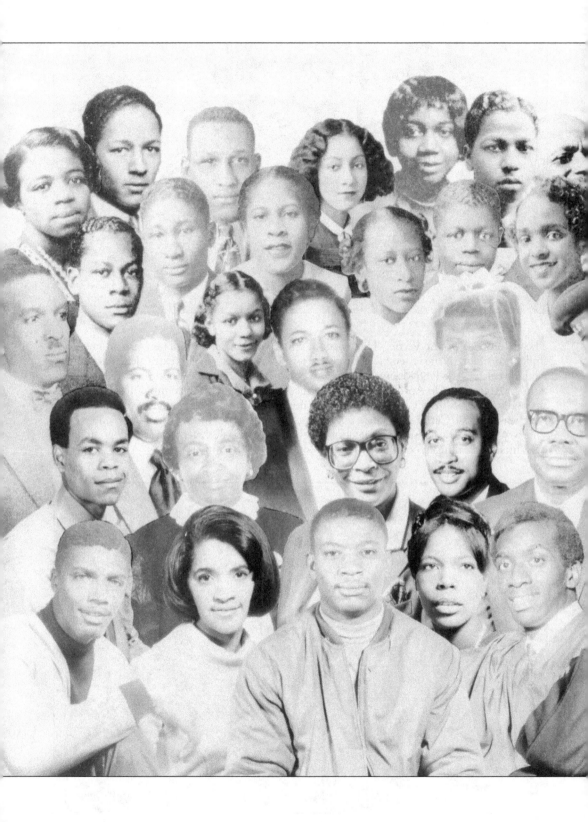

This mural-sized composite photograph was part of a 1994 history exhibition, A Time to Remember, held at AC-BAW Center for the Arts Gallery, at 128 South Fourth Avenue. The images were assembled from the Rufus Merritt Collection, personal family albums, and public and private archives. The featured individuals were from many of the city's oldest African American families. The photograph was illustrative of the city's ethnic and sociopolitical realignments. Between 1955 and 1965, the swelling southside African American population wrote a new chapter in the city's history. The steady growth of Portuguese and Latino residents represents a potential millennial redefinition of what it means to be a resident of the "Four Square." Among those shown in the mural are, in no particular order, Dorothy Coleman, Charles Graham, Brenda Dowry, Gregory Robeson Smith, Gray Pretlow, Wilamena Streeter, Minne G. Lance, Walter Prevost, Wendell Thompson, Lindley Smith, Edward Williams, Gurney Woodley, George Hill, Julia Jackson, George Hewlin, Gwendolyn Marshall, Mary Brown, Grace Thompson, Mary Weston, Rosalie V. Smith, Wayman Williams, Sarah Bradley, Larry Smith, Mary Cohen, Rufus Merritt, Garrett Young, Pete Conn, Mama Conn, Stewart Coleman, Uniformed soldier, Ruben Tyree, Linda Smith, Larry West, James Horsey, Magretta Jeffers, ? Solomon, ? Vaughn, and Pete Haddock.

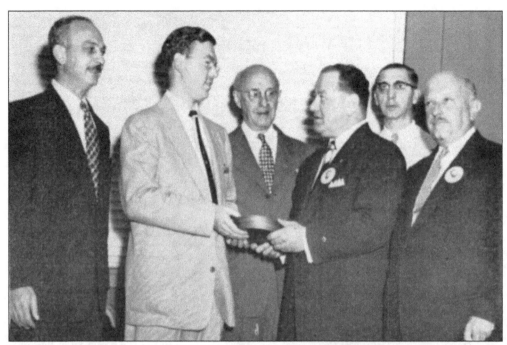

From September 27 to October 3, 1953, Mount Vernon celebrated the centennial of its incorporation as a village. It held a three-hour parade with 100,000 spectators lining the three-mile route. The history-themed events included a historical 800-foot color film of the city's heritage sites. Above, Mayor Joseph Vaccarella receives the film. Behind him are local historians Dr. Alfred Franko (center) and Otto Hufeland (second from right). The film has been missing for 30 years. Below is a photograph of the closing ceremony, at which Mayor Vaccarella buried items in a time capsule in front of city hall, to be retrieved at the 2053 bicentennial. From left to right are Joseph Rentano, Arthur A. Berard, Elmer Hildreth, John K. Miller, Louis Nardone, an unidentified police officer, and Robin "Dagmar" Morgan. Perhaps a copy of the film was placed in the time capsule. (Below, courtesy of the Mount Vernon Chamber of Commerce.)

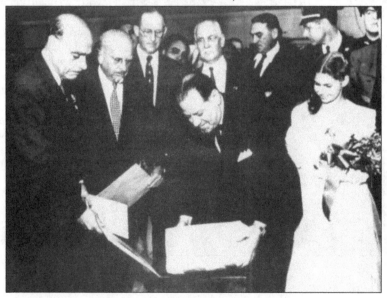

Four

MILLENNIAL
MOUNT VERNON

A city's future is determined by the hopes and will of its taxpayers. From 1892 to 1925, Mount Vernon officials chose multifamily housing and industrial and commercial development as the path to progress. These policies betrayed the founders' suburban goals and did not create the intended long-term prosperity. Several proposals to cover the railroad cut were never implemented. With limited real estate for commercial and residential development, Mount Vernon built high-rise facilities, further blending city aesthetics with its urban neighbors. In addition, there has been no progress in cleaning and restoring Eastchester Creek to its former usefulness. Millennial hopes for suburban reclamation are fading.

Mount Vernon possesses a deep reservoir of talented residents. From coast to coast, people have come to know the city as "Money Earnin' Mount Vernon," a term coined by the late hip-hop artist Dwight "Heavy D" Meyers. Among its populace are great artists, clergypersons, educators, ambitious business owners, progressive politicians, and proud home owners. The entire community has been called to stand together in neighborhoods and houses of worship to look beyond the difficult present to a promising tomorrow.

The 2053 bicentennial celebration provides a window of opportunity to reinvent, rebuild, and re-brand the city. The idea of revisiting the history of the community is a journey back to the future. The city's present dilemma is not new. It is historical, largely related to the underutilized and abandoned industrial properties along Eastchester Creek and the Bronx River. The city must develop an affordable plan to cover "the cut" with a viable commercial redevelopment vision that includes Fourth and Gramatan Avenues.

Finally, rethinking the meaning of small communities and the role that educational, cultural, and commercial entrepreneurship play in determining the quality of life are at the core of the city's bright tomorrow. It is hoped that a bold economic and social redesign of public and educational services will overcome the divisive politics and policies of the past. Critical to envisioning a different millennial Mount Vernon is to consider a return to smaller, consolidated neighborhoods joined together for the common good over the railroad cut. How and when that gets done is limited only by the residents' collective creativity, perseverance, and willingness to invest its treasure and time to this noble cause. Our beloved city is resilient. We can and will do this. The clock is ticking; 2053 is on the horizon. Let's get ready!

After World War II, increasing high school enrollments, inadequate instructional programs, and outmoded facilities were pressing educational challenges. On May 16, 1955, there was a public hearing at Davis High School about construction solutions to inadequate and overcrowded secondary schools. There was intense debate over new construction, modification of existing buildings, and the cost and location of an ultramodern, comprehensive high school. Should the school be in central city near the railroad, or on underutilized acres along the Pelham and Bronxville borders? Ruth Lemos (left) was the first school trustee of Portuguese American descent, and Dr. James Thornton (below) was the second African American trustee. They were members of the policy board that oversaw the planning and construction of the controversial new high school, which combined Davis's college preparatory courses with Edison's vocational curriculum. The comprehensive high school was built on Baker's Field, on the far northeast side of the city.

The photograph above, taken in 1962 from the Cross-County Parkway, shows the rear of the state-of-the-art Mount Vernon High School, which had an award-winning design. The school, with its modern facilities and technology, was built to serve as the city's flagship educational institution. There was controversy about where to build the school. Some thought center city was the most accessible and best location, hoping it would help bridge the divisions between the north and south sides. Those advocates were disappointed. It was built on the city's wealthy far northeast side. The landscaped courtyard (below), bridged by the school library, is located in the center of the school. This air-conditioned, sprawling, two-level school was Mount Vernon's consummate mid-century declaration of its authentic suburban credentials.

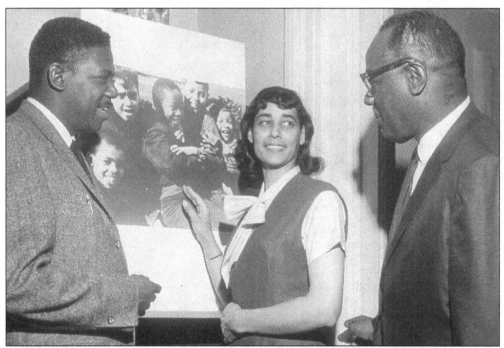

Above are Lloyd King of the NAACP (left), school board candidate Mary Ellen Cooper (center), and Alex Young, activist and resident of Levister Towers. They were concerned about Mount Vernon de facto school segregation based on residential patterns and neighborhood schools. They raised the issued of equity of instruction, services, and resources between northside and southside schools. Cooper won seats on the school board in 1963, 1968, and 1969. By mid-century, Mount Vernon Hospital was planning for modernization and expansion. Pictured below at the hospital's 1960 Century Club annual dinner are, from left to right, Dr. Abraham and Mae Feldman; Dr. and Mrs. Barlin; Dr. and Mrs. Robert Rosen; and, at far right, Dr. Eugene and Virginia McClellan Moskowitz. Mrs. Moskowitz later became a beloved city historian. The library's local history room is named in her honor.

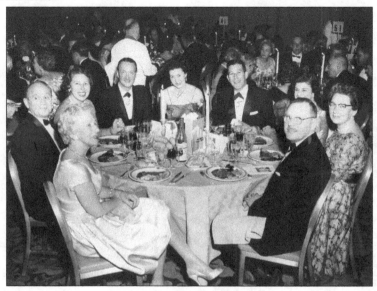

Dr. Herbert Cave (right) was one of the Harlem Hospital physicians who helped save Dr. Martin Luther King's life after he was stabbed by a deranged woman in 1958. In the photograph below, an arrow points to the knife just below Dr. King's chin. On April 3, 1968, in Memphis, Tennessee, the night before his assassination, King recalled that the attending doctors told him that the knife was so close to a critical artery that, if he had simply sneezed, he would have bled to death. In his last, prophetic "Mountain Top" speech, Dr. King said he received a letter from a schoolgirl in White Plains, who wrote, "I am so glad you didn't sneeze." The nation and the world would have been different if he had. Dr. Cave was a Mount Vernon political and civil rights activist.

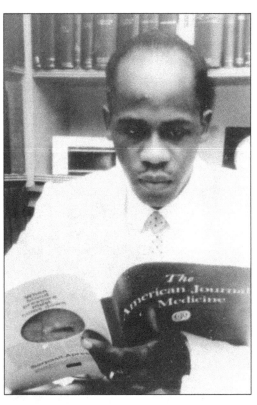

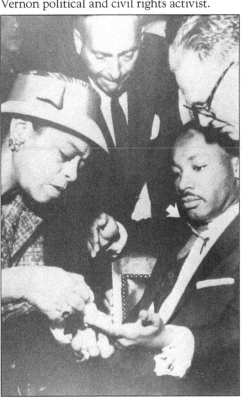

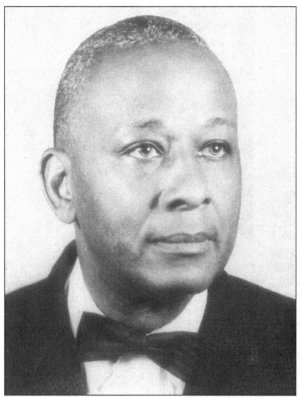

By the 1960s, the southside schools were de facto segregated institutions due to the area's African American population. A vocal protest movement demanded integration of neighborhood schools and faculties. In 1965, Dr. Clinton Young Sr. (left) was hired as the district's first African American principal. He became the leader of Nathan Hale Elementary School, now known as Cecil H. Parker School. In 1982, his son Clinton Young Jr. and Marlene Dandridge were elected to the school board. Young Jr. became the first African American president of the board of education. The corner of Seventh Avenue and Third Street (below) was the heart of the African American community. The flight of white and middle-class southsiders left a core of disadvantaged and working poor in the densely populated sector.

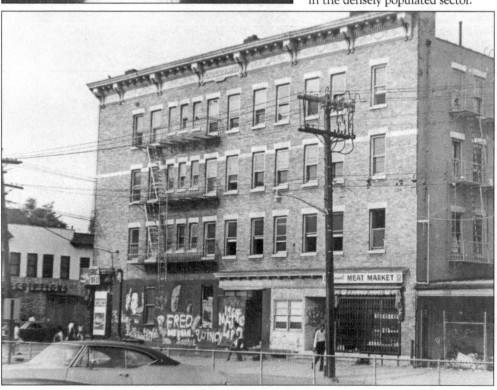

After the 1968 assassination of Dr. Martin Luther King, youthful "Black Power" militants were able to influence local politics once dominated by advocates of "interracial cooperation." They demanded expanded African American political participation and empowerment. Above, Black Power advocates pose in August 1968 on South Seventh Avenue. Among them are Benjamin Smalls (far left) and Charles Stevens (fourth from right). In 1964, Rev. Samuel Austin (right) became pastor of Grace Baptist Church. He was active in the civil rights movement and marched with Dr. King. In 1968, he was the first African American to run for Mount Vernon mayor. He ran as a third-party candidate with a large African American constituency willing to break with both the Democratic and Republican Parties. He ushered in the possibility of successful black political participation at the highest level of city governance. The divisive nature of his candidacy led him to withdraw from the race. He served at Grace until 1975.

Part of the success of Mount Vernon Schools was the stability of long-serving superintendents. Dr. William C. Prattella (left) served as superintendent from 1972 to 1997. His challenges were the rapid growth of the African American population, disparities in changing schools, and a racially, socially, and economically divided community. In 1994, he said, "We must create a new vision, a dramatic vision, one that will lead us well into the 21st century and keep Mount Vernon Schools in the leadership role it has held in the past." During his tenure, Mount Vernon hired more African American educators than any other Westchester community. He retired in 2001 and continues to serve as a distinguished full professor of education leadership at Mercy College. Below, Rev. Martin Luther King Sr. ("Daddy King") is seated in a 1977 photograph. He is surrounded by, from left to right, Rev. Franklyn Richardson of Grace Baptist Church; Ben Anderson, editor of the *Westchester Observer*; Rev. Belvie Jackson of Centennial AMEZ Church; and Mayor Thomas Sharpe. (Left, photograph by Theodore Jenkins.)

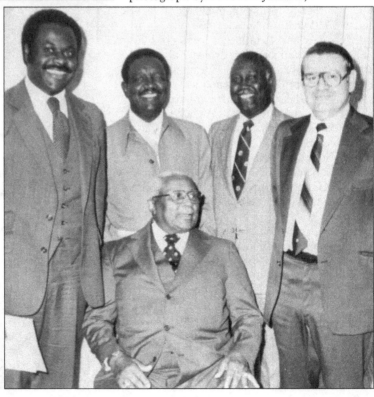

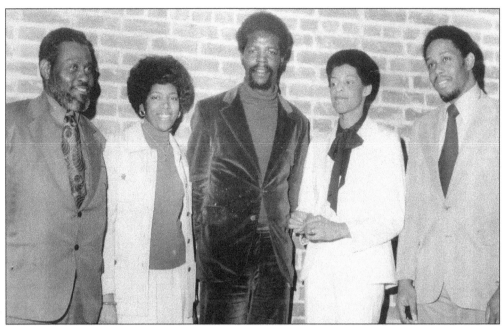

Seen above in 1977 are school board candidates (from left to right) Godrey Jackson, an unidentified candidate, Charles Green, Ruth Hassell-Thompson, and Stephen Fowler. It took another two decades to achieve an African American majority on the school board. In 1975, Hassell-Thompson ran unsuccessfully. In 1993, she was elected to the Mount Vernon City Council, serving as president and acting mayor. In 2000, she was elected to the New York State Senate and continues to represent parts of Bronx and Westchester Counties in Albany. Below, the late Anthony Veteri (left) and James Auteri register as candidates for the 1979 school board. They were successful. Veteri was a National Football League (NFL) referee. His son, a former school director of athletics, followed his father, and they became nationally recognized father-and-son NFL officials. Veteri Sr. left a memorable quote about his lifelong love for the city: "If St. Paul's Cemetery was still burying people, I would never have to leave Mount Vernon."

At left, renowned artist George Wilson is painting the official portrait of Cecil H. Parker, the city and county's first African American educator. The portrait was funded by IBM and unveiled on October 13, 1983, when Nathan Hale Elementary was renamed in her honor. The portrait is prominently displayed in the school lobby In 1990, Nelson Mandela was released from prison and worked for a nonviolent solution to apartheid. In 1993, Mount Vernon was the first public school district to name a school in his honor. Mandela was elected president of South Africa the following year and received the Nobel Peace Prize. Grace Baptist's Rev. Franklyn Richardson obtained a letter (below) from the South African president. It reads, "To my friends, the students of the Nelson Mandela Community School in Mt. Vernon, New York. Compliments and best wishes to a centre of education whose symbolism links two continents." (Left, courtesy of Alif Archives; below, courtesy of the Nelson Mandela Alternative School.)

NELSON MANDELA

Do my friends, The Students
at the Nelson Mandela
Community school in Mt. Vernon,
New York.
Compliments and best wishes
to a centre of education whose
symbolism links two continents

Mandela
3 . 10 . 94

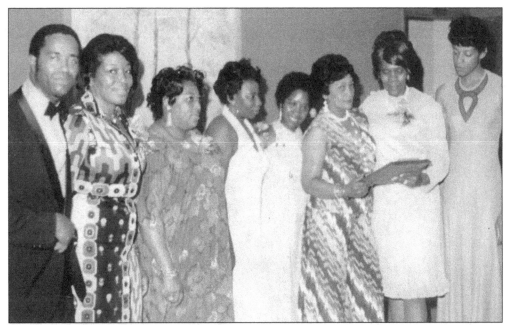

Shown above at a 1973 Young Mothers Educational Development (YMED) fundraiser is the late Dr. Betty Shabazz (second from left), widow of Malcolm X (El Haj Malik Shabazz). She was a health teacher in the innovative program for young, unwed mothers. Also pictured are, from left to right, aspiring politician Ronald Blackwood, ? Gadson, Sarah Brooks, two unidentified women, Mattie Smalls, and Ruth Hassell-Thompson. The controversial congresswoman Bella Abzug (below), known for her hats and radical feminist and civil rights politics, sold her Vernon Heights house on East Fifth Street to Dr. Shabazz, who raised her five daughters there. The city is considering the house as a local historical site and part of a Mount Vernon heritage tour. (Above, photograph by William Thomas.)

Above, on January 2, 1976, Republican mayor Augustine Petrillo, born in Mount Vernon in 1911, is sworn in for a third term by Judge Raymond P. Sirignano, a childhood friend and former mayor. Petrillo served as mayor from 1968 to 1976. Below, Mayor Petrillo speaks to dignitaries assembled for the ground-breaking of the Lefrak Organization's Westchester Plaza. The $30 million urban renewal, "middle-class," cooperative housing project near the train tracks consisted of five buildings and 423 apartments. The most ambitious downtown capital program in the city's history, it was designed to set the social and economic direction of the city well into the 21st century. (Below, courtesy of the Mount Vernon Republican City Committee.)

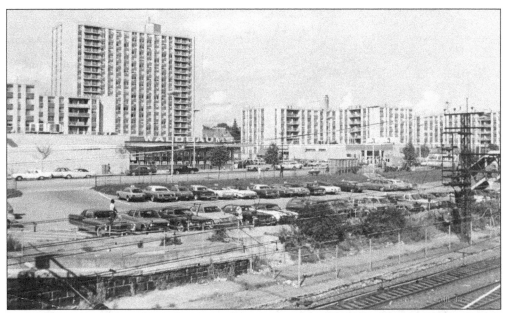

In the 1970s, the city took a redevelopment page from New York City and built Westchester Plaza (above), a middle-class cooperative overlooking the railroad depot. Its amenities included a supermarket, a swimming pool, tennis courts, parking, and the latest security devices. It was the most promising preparation for next-century middle-class growth and prosperity. Located on the north side of the tracks, it was intended to initiate the gentrification of the troubled southside. To date, the cooperatives have not lived up to their social and economic expectations. Below, on January 2, 1979, the city council posed for a photograph. The president was Ronald Blackwood (seated), a Republican. Upon the 1976 death of Mayor Augustine Petrillo, Blackwood became the interim mayor. He lost a bid to be the Republican candidate in the special election. By December 1979, Blackwood had become a Democrat. Also in the photograph are, from left to right, two unidentified officials, Nancy Fitch, Joseph Ragno, Ron Wiersma, and David Avestrieh.

Above, on January 1, 1977, after the death of Mayor Augustine Petrillo, Democratic mayor-elect Thomas Sharpe is sworn into office by Judge Isaac Rubin. In the background are, from left to right, Rev. Belvie Jackson, pastor of Centennial AMEZ Church; Viola Sharpe, the mayor's wife; and Rev. Harry Aufiero, pastor of Community Church at the Circle. Below is a January 3, 1977, photograph of incoming mayor Thomas Sharpe (left) meeting with cabinet members and city officials. Among those pictured are two future mayors, Carmella Iaboni (second from the rear, far right) and Ernest D. Davis (first row, second from right). (Both courtesy of David Ford, former chairman of the Mount Vernon Democratic City Committee.)

Upon the 1984 death of Mayor Thomas Sharpe, city council president Carmella Iaboni (right) became interim mayor. She was the first woman to serve as the chief executive of the city. Below, on December 26, 1979, David Ford (left) and Mayor Thomas Sharpe (center) register Ronald Blackwood as a Democrat. Blackwood was previously rejected for the Republican candidacy for mayor after Mayor Petrillo died in office. Sharpe, a Democrat, won the 1976 election. Unexpectedly, Mayor Sharpe also died in office. Blackwood ran as a Democrat and, in November 1985, became Mount Vernon's first African American mayor, holding that distinction for the entire state of New York. The city was proud of the necessary interracial cooperation to make this stunning victory part of New York history.

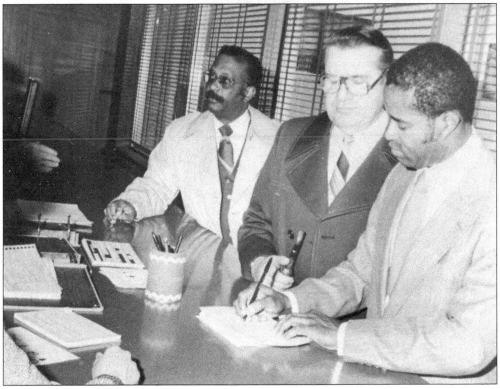

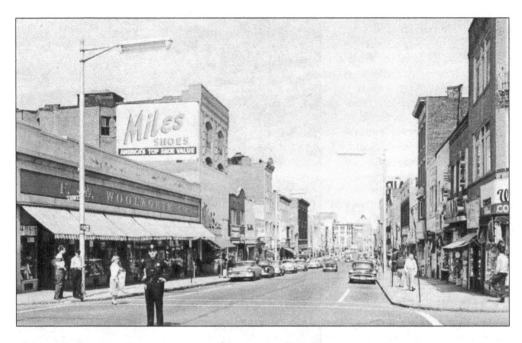

In the second half of the 20th century, the old shopkeepers on "The Avenue" closed their doors when their children did not return to carry on the businesses. The quality and diversity of the new enterprises did not measure up to the shops that lined Fourth Avenue in its golden days, when customers from across the county came to the city to patronize the stores. The Woolworth's (above, at left) at the northwest corner of Second Street and Fourth Avenue was torn down and replaced with a less-than-memorable McDonald's (below). The fast food restaurant later closed, and the site became an open-air fruit and vegetable market.

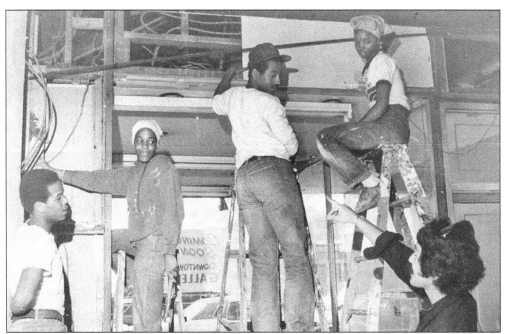

Above, the Arts Construction Corps of the Association of Community-Based Artists of Westchester (AC-BAW) converts an old warehouse at 128 South Fourth Avenue into a fine art gallery in 1979. From left to right are corps associates William Daniels, Toya Cooper, William Thornton, Andre Vann, and Alan Amioka, project administrator. Students not pictured were Crystal Gist, Kenneth Harris, Ricky Lum Cheong, and Ernest Allen. Mayor Thomas Sharpe supported the artists' proposal for the coordination of culture and commerce in the downtown district. Millennial Mount Vernon will have to use "sweat equity" in a similar fashion in every aspect of its community redevelopment plans. The art gallery (below) is celebrating over 30 years of exhibitions and arts programs. It survived government budget cuts and remains a community-based model for individual, public, and private-sector collaborative support. It is the only professional art gallery in the city.

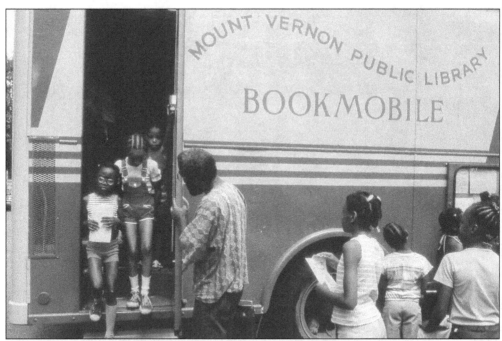

For most of the 20th century, the Mount Vernon Public Library was Westchester County's central library and leader in mobile library services. The Mount Vernon Bookmobile is seen above serving children at Levister Towers. Artist Donald Robertson helps the children down the steps as they continue on to the Fourth Street playground to participate in a 1978 summer arts and literacy program, Westchester Artists in the Streets (WAITS). The bookmobile was discontinued in the 1990s. Guy Davis (below) is a blues and folk guitarist and actor. In July 1978, he was the lead musician in the WAITS program, which delivered music, visual arts, and storytelling to children for what Robertson called the "developing communities" of Westchester County. Davis is leading young people in a song and march around the playground. He is the son of late actors and activists Ruby Dee and Ossie Davis. (Both courtesy of AC-BAW Center for the Arts.)

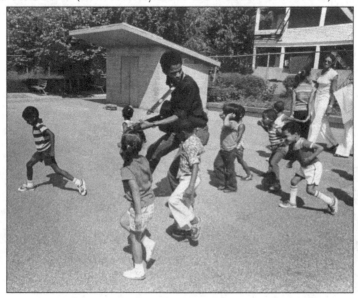

High school actors fully utilized their new "Little Theater" and 1,500-seat auditorium. Above, in 1967, cast members of *Stop the World—I Want to Get Off* take time out from rehearsal. They are, from left to right, (first row) Ronnie Massin, Bob Rosenbaum, Shelia Jackson (standing), Cecelia Cohen, and Susan Kaplan; (second row) Ernest Smith, Michelle Newsam, Robert Cobb, Lavern Jeffers, and Michael Giles. Below, the cast of Open Cage Theater's 1992 production of *To Be Young, Gifted and Black* poses at Mamaroneck's Emelin Theatre. Pictured from left to right are (first row) Lenn Washington, Justine Elias, and the founder and director of the theatre company, the late Tina Sattin; (second row) Ken Moses, John Lorusso, Helen Nelson, Karen Elias, Verlyn Walters, and Amina Henry; (third row) Meera BeHarry, Linda Potrafke, Tom Watson, John Bennett, Hugh Abel, and Ernest Noce. (Below, courtesy of Tina Sattin and the Open Cage Theater.)

Linda Fairstein (left), a New York City attorney and prolific novelist, was born in Mount Vernon and is a 1965 graduate of the high school. She is an American feminist author and a former prosecutor focusing on violent crimes against women and children. From 1976 to 2002, she served as head of the Manhattan District Attorney's sex crimes unit. During her tenure, she prosecuted several high-publicity cases. She is the author of a series of bestselling novels featuring Alexandra Cooper, a fictional Manhattan prosecutor. Art Buchwald (below) was born in Mount Vernon on October 20, 1925. The award-winning humorist was known for his long-running syndicated column in the *Washington Post*. In 1982, he won a Pulitzer Prize for outstanding commentary, and he wrote his memoir, *Leaving Home*, in 1994. He was the author of over 30 books and wrote until his death. On January 17, 2007, Buchwald died of kidney failure. The next day, the *New York Times* website posted a video obituary in which Buchwald himself declared, "Hi. I'm Art Buchwald, and I just died." (Below, photograph by Dr. Larry H. Spruill.)

Alexander "Alex" Briley (top, center), a 1969 Mount Vernon High School graduate, was introduced to Village People producer Jacques Morali by band member Victor Willis. He went on to arrange most of the group's vocals and harmonies. During the disco era, Briley took the role of a soldier for the 1978 album *Cruisin'*. In 1979, he appeared as the sailor when the group recorded "In the Navy." The Village People have become an iconic music symbol of gay and lesbian culture and issues. Dwight E. Myers (below), better known as "Heavy D," grew up in Mount Vernon. He was a beloved rapper, record producer, actor, and leader of Heavy D & the Boyz. In 1987, he coined the term "Money Earnin' Mount Vernon." He rapped, "Listen to this rap / 'Cause I'm about to go down an put my town on the map / MC Heavy D, delighted you'll be learnin' / About the place where I rest, Money Earnin' Mount Vernon." His success identified the city with the origins of rap music. On November 8, 2011, at age 44, Heavy D passed away. His star-studded funeral was held at Grace Baptist Church. (Below, courtesy of the Myers family.)

Shown above are the late Ossie Davis (left), an American film, television, and Broadway actor, director, poet, playwright, author, and social activist, and Hollywood star Denzel Washington. In the 1950s, Davis and his wife, Ruby Dee, moved to Mount Vernon. He was close friends with Martin Luther King and Malcolm X. He served as the master of ceremonies at the 1963 March on Washington. In 1965, Davis delivered the eulogy at Malcolm X's funeral. The city misses his nobility and wisdom. The late Richard "Dick" Clark (left), a 1947 Davis High graduate, was an American cultural icon, known for hosting *American Bandstand* from 1957 to 1987. He also hosted *Dick Clark's New Year's Rockin' Eve*, which transmitted Times Square's New Year's Eve celebrations. *Bandstand* was the first national television entertainment program to show racially integrated performances and studio-audience seating. He is considered responsible for creating a national youth culture. His enduring youthful appearance earned him the nickname "America's oldest teenager." (Above, photograph by Dr. Larry H. Spruill.)

On September 1, 1975, John R. Branca (below, second from left), commissioner of recreation, hosted a concert by Michael Jackson and the Jackson Five (right) at Memorial Field. It was part of a series that included Stevie Wonder, James Brown, Jerry Vale, Marianne Faithful, Jose Feliciano, and Ella Fitzgerald. Facilitating the appearance of these music stars was his son, John G. Branca (below, second from right). The photograph below was taken at Memorial Field in 1975. John Gregory Branca was a rising entertainment lawyer representing rock 'n' roll acts, music publishing catalogs, and independent music labels. Over the past four decades, he has represented 29 acts in the Rock and Roll Hall of Fame, including the Rolling Stones, Aerosmith, Fleetwood Mac, the Doors, Berry Gordy, Dr. Dre, and Justin Timberlake. Branca was executor in the Michael Jackson probate case. Since Jackson's death, the estate has generated $600 million in income, erasing the $500 million debt it had at the time Jackson died. (Both courtesy of Paul Caramuto.)

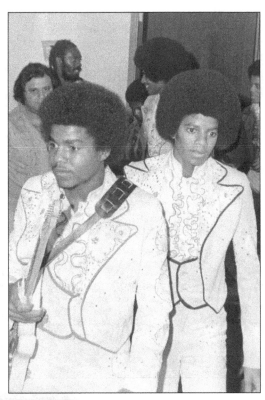

Alvin Queen (left) started playing drums at eight years old. At 14, inspired by Art Blakey, Philly Joe Jones, and Elvin Jones, he met John Coltrane and Horace Silver and was skilled enough to sit in with them. Queen worked with George Benson, Milt Jackson, Oscar Peterson, and Pharoah Sanders. In 1979, he moved to Switzerland. He is one of the world's most versatile drummers and represents a link between the great masters of the 1950s and 1960s and the world of contemporary jazz. Esther Hinds (below) is an award-winning operatic soprano whose extensive roles have ranged from ladies of Mozart operas to the heroines of the works of Bellini, Puccini, Verdi, Strauss, and Wagner. Her concert appearances include performances with the Berlin Philharmonic and the Boston, St. Louis, San Francisco, and Toronto Symphonies. At the Spoleto Festival, she received the coveted Pegasus Award, the festival's highest recognition. She won a Grammy Award for her recording of Barber's *Antony and Cleopatra*. In February 1987, she introduced opera to students at Mount Vernon High School. Both opera and Hinds were well received. (Left, courtesy of Alvin Queen; below, courtesy of Esther Hinds.)

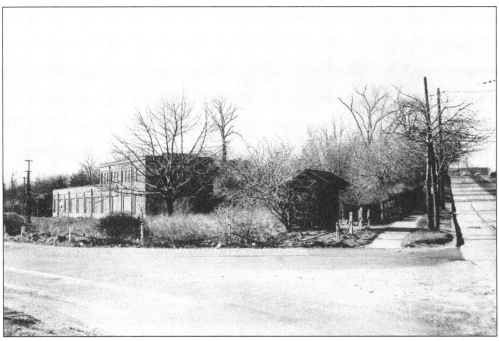

Most millennial Mount Vernonites would not recognize the southeast corner of Garden Avenue and Sandford Boulevard above. It was the last 300 yards of the old Boston Post Road as it crossed the Hutchinson River into Pelham. Opposite this corner is Memorial Field. The road on the left leads to Hutchinson's Field. Today, it is the heart of the city's most successful commercial enterprise zone (below), at the east end of the Sandford Boulevard redevelopment project. Mayor Ernest Davis oversaw the completion of the Target and Best Buy shopping complexes and is currently renovating Memorial Field. (Below, courtesy of the Mount Vernon Planning Department.)

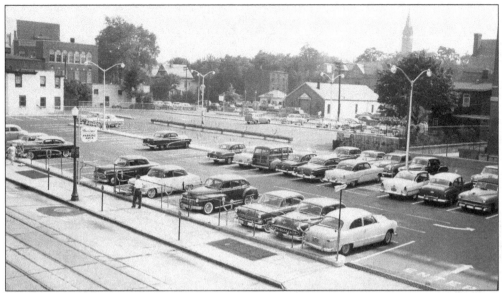

These two 1950s photographs of Fifth Avenue between First and Second Streets represent an important Mount Vernon millennial opportunity. The new parking lot (above) was built to meet the parking needs of the merchants on Fourth Avenue and Wood Auditorium. In addition, the growth of Grace Baptist Church and Sacred Heart Catholic Church enabled them to take advantage of the lot as a solution to their Sunday parking problems. Below is the 1956 Mount Vernon Telephone Company building. Westchester County Community College will be moving its satellite campus to the building, as a relief from parking shortages and congested traffic on Gramatan Avenue. The college is becoming the beacon of intellectual life in the Four Square. The Fifth Avenue parking lot will serve its faculty and students well.

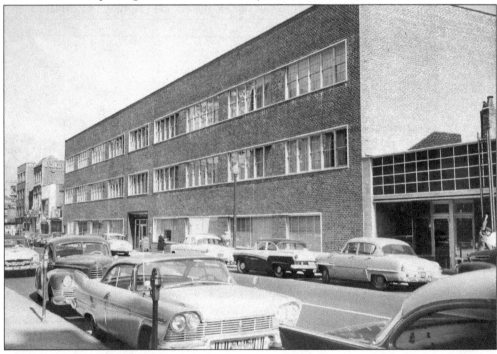

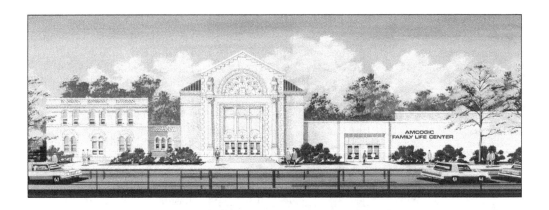

In the past decade, Allen Memorial Church of God in Christ (AMCOGIC), formerly located at 410 South Ninth Avenue, followed in the footsteps of Grace Baptist Church, Macedonia Baptist Church, and Greater Centennial AMEZ Church. In 1998, pastor Carlton C. Spruill moved the church to 132 Crary Avenue and conducted a multimillion-dollar purchase and renovation of Sinai Temple, a synagogue near Hartley Park. On September 1, 2011, Mayor Clinton Young and the city council renamed Crary Avenue as Allen Memorial Church Plaza. Below, city officials and dignitaries unveil the new street sign. (Both courtesy of AMCOGIC archives.)

In 1968, the late Dr. Belvie Holland Jackson Jr. and Shirley Jackson, former pastor and first lady of Greater Centennial African Methodist Episcopal Zion Church, came to Mount Vernon and oversaw the transformation of the South Eighth and Ninth Avenue corridors from Fourth Street to Sandford Boulevard. They were leaders in building affordable housing. In 2014, Centennial will construct the 25,000-square-foot, $100 million Rev. Belvie and Shirley Jackson Family Life Center adjacent to the church. (Courtesy of Shirley Jackson.)

This is an artist's rendering of the millennial expansion of Grace Baptist Church. The scale of the construction plan is aligned with the gradual acquisition of adjacent Sixth and Seventh Avenue properties. It is an enormous commitment to the future of the people and the city. The "Village of Grace" is changing the face of the city while currently managing nearly 400 units of affordable and senior housing, with other developments on the way. Grace's ministries are working to make Mount Vernon a safer, healthier, and more prosperous place to live. (Courtesy of Shirley Jackson.)

Photographers chronicle milestones of people, institutions, and government. Mount Vernon has had many photographers performing this documentary function. From 1940 to 1985, the most prolific recorders of city life were Paul Caramuto (right) and Rufus Merritt (below). Caramuto's vast negatives and print archive spans the 1930s through the 1980s. Upon his death, his family took his archive, leaving behind contact sheets and prints of the fire, police, recreation, and planning departments, city council, and various mayoral administrations.

After Merritt's death, Rumar Studio, on South Fourth Avenue between Third and Fourth Streets, left a comprehensive record of Mount Vernon's African American families, personalities, churches, social events, and businesses. His wife donated his negatives to Alif Associates. Alif will donate them to the library. This book is a tribute to their body of work.

Visit us at
arcadiapublishing.com

CPSIA information can be obtained
at www.ICGtesting.com
Printed in the USA
LVHW010044070520
654940LV00018B/1199